Beads of Glass

The Art *and the* Artists

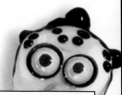

Editor in Chief
Ed Weisbart

Art Direction, Design, Layout and Photo-retouching
Debbie Mackall, Dimensions in Media, Inc.

Computer Illustrations
Ed Weisbart

Photography
Martin Konopacki, still photography
Ed Weisbart, action photography
Additional photography as noted

Editorial Assistants
Kathy Anderson
Ellen Black
Noreen Gallivan
Rose Griesmyer
Kim Hickcox
Laura McPherson
Carol Neithercut

Library of Congress Cataloging-in-Publication Data
Library of Congress Control Number: 2002113295
SAN 255-0288
Jenkins, Cindy 1953 –
Beads of Glass: The Art and The Artists / Cindy Jenkins
Beads

10 9 8 7 6 5 4 3

Published by Pyro Press, a division of Jenkins Crafts, Inc.;
USA

© 2006 Pyro Press
Telephone: 800-347-3387
Email: beadmakers@aol.com
www.hotheadglass.com

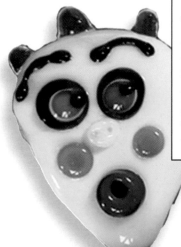

Beads of Glass

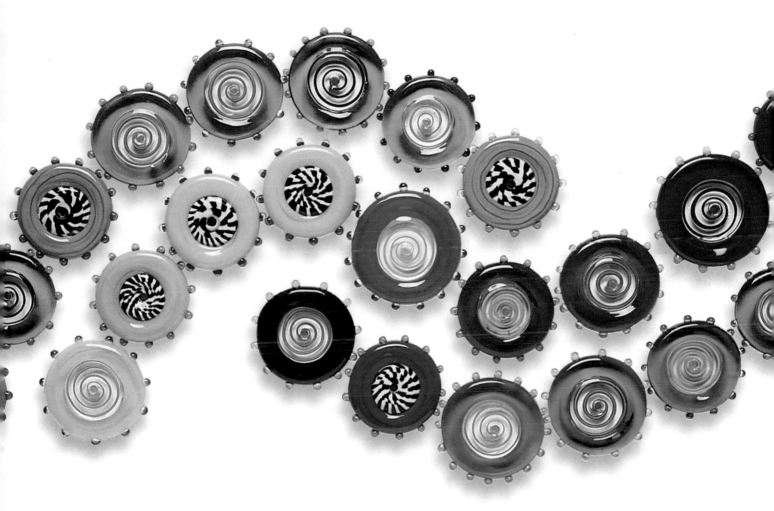

Cindy Jenkins

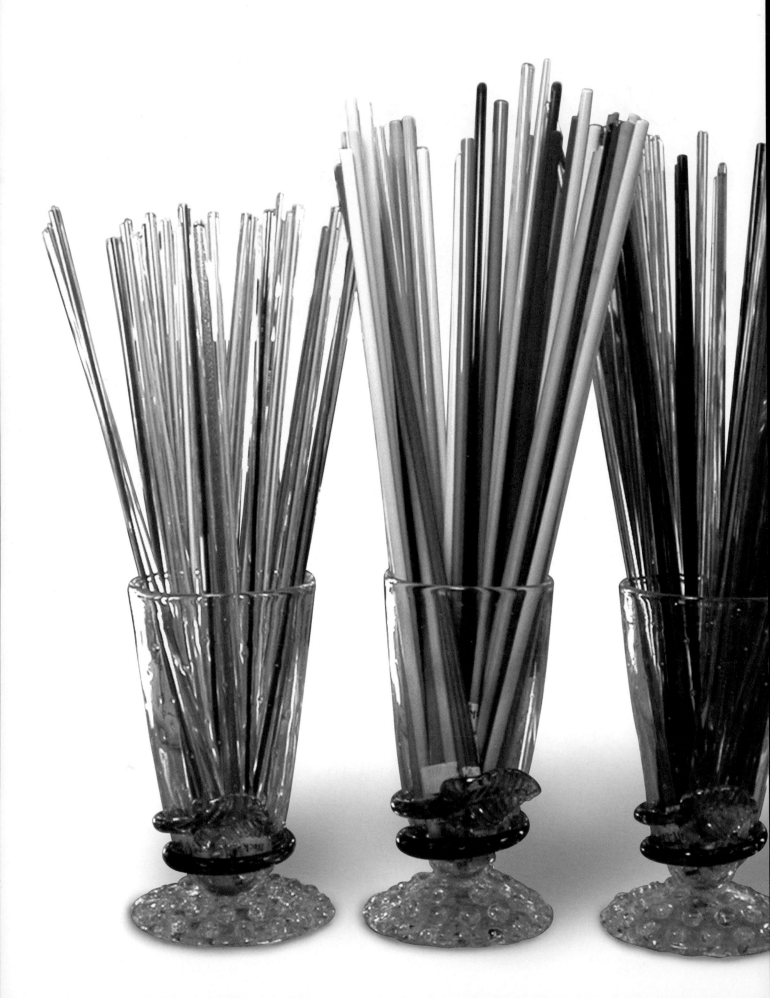

Table of Contents

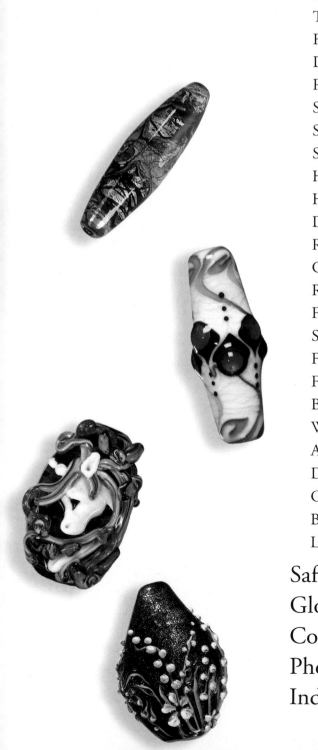

Introduction

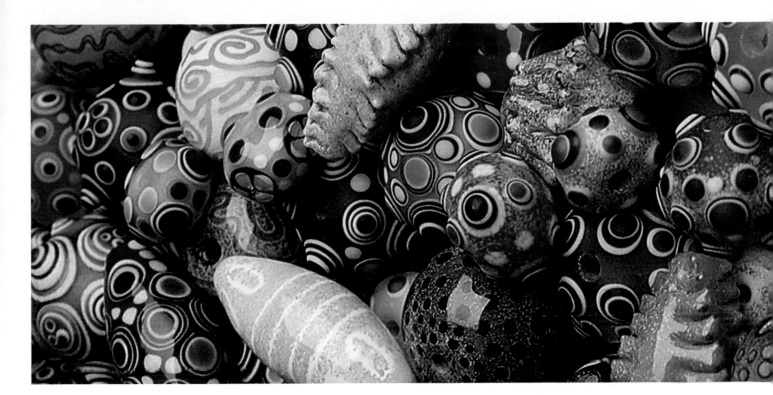

The glass beadmaking industry has exploded over the past ten years. It began quietly in the 1960's with a couple of intrepid pioneers. By the mid 1980's there were only a few small pockets of beadmakers in the United States, most notably the Pacific Northwest. Today beadmaking has become a thriving industry with many suppliers, teachers and full-time beadmakers spread throughout the United States.

When I began to take an interest in glass beadmaking in the late 1980's, there were no classes, books, videotapes or teaching materials to be found. (I always like to learn things the hard way!) Now the International Society of Glass Beadmakers has celebrated their thirteenth year; their membership has grown from about eighty in 1993 to well over thirteen hundred in 2005, with regional, state and local chapters. There seems to be no end to the number of people taking an interest in this recently resurrected ancient art form.

Over this time, the beads have evolved from simply decorated spheres to incredibly complex works of art. The art glass world, which traditionally paid little attention to what it thought of as inconsequential little trinkets, has had to sit up and take notice. Art galleries that never before even looked at beads are now vying to be the ones to showcase juried bead shows. As the lampworking movement has entered the mainstream, many people have become curious about the people behind the beads. It is natural to want to connect a face to the art and to wonder what path brought them to lampworking as their chosen field. The artist pages in this book will help you to make that connection.

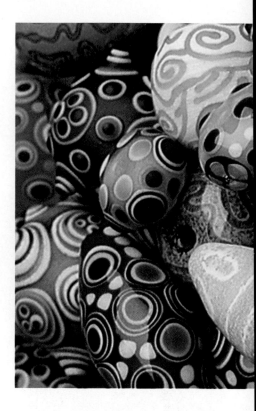

I am constantly amazed at the ingenuity of new as well as seasoned beadmakers. Because beadmakers come from all walks of life, there is a constant influx of fresh ideas from areas such as engineering, medicine and computers, as well as from other art forms including photography, interior design, fiber arts, ceramics, sculpture and even blacksmithing. These artists each bring their individual skills and worldviews, further enhancing the craft. Many have designed new tools and equipment. Scores of new businesses have sprung up. There is so much sharing of knowledge going on that it has allowed the craft to grow exponentially. It's an exciting time to be involved.

As recently as fifteen years ago, many bead artists had to learn this craft in isolation. Because of this, they came up with their own special ways of doing things. I always believe in learning from as many people as possible, because no single way of doing something works for everyone. Sometimes just a minor tweak to the way you approach a problem makes all the difference.

I have gathered as many of the beadmaking pioneers as I could for this book. There are also a lot of fresh new faces represented here with their completely different spins on things. They have generously shared their hard-won knowledge, including their favorite tips and techniques, hoping to make the whole process easier for everyone. The tips range from quite basic to innovative and challenging. I have tried to portray the broadest possible assortment of beads and techniques. This collection represents years of work, experimentation, trial and error and lots of brain-picking. It will save you years of frustration.

Glass beadmaking has come a very long way in a short amount of time. There's no telling how far this can all go. I, for one, can't wait to see.

—Cindy Jenkins

The Beads

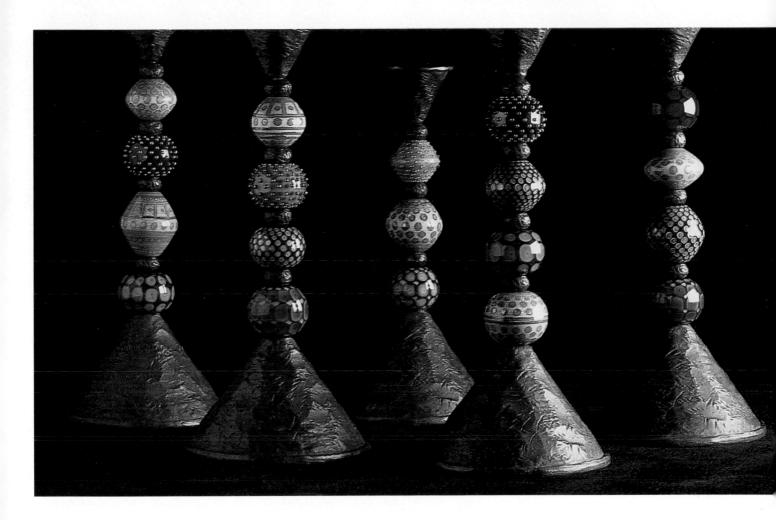

The following gallery pages celebrate the beauty and diversity of contemporary lampworked glass beads.

Enjoy!

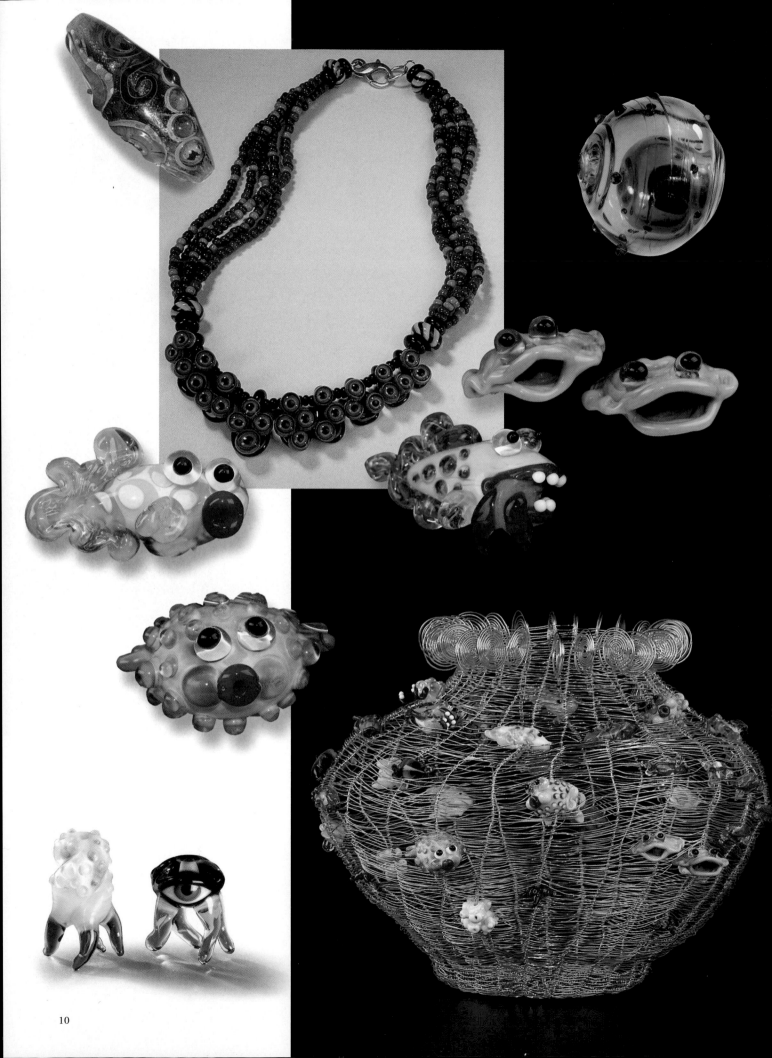

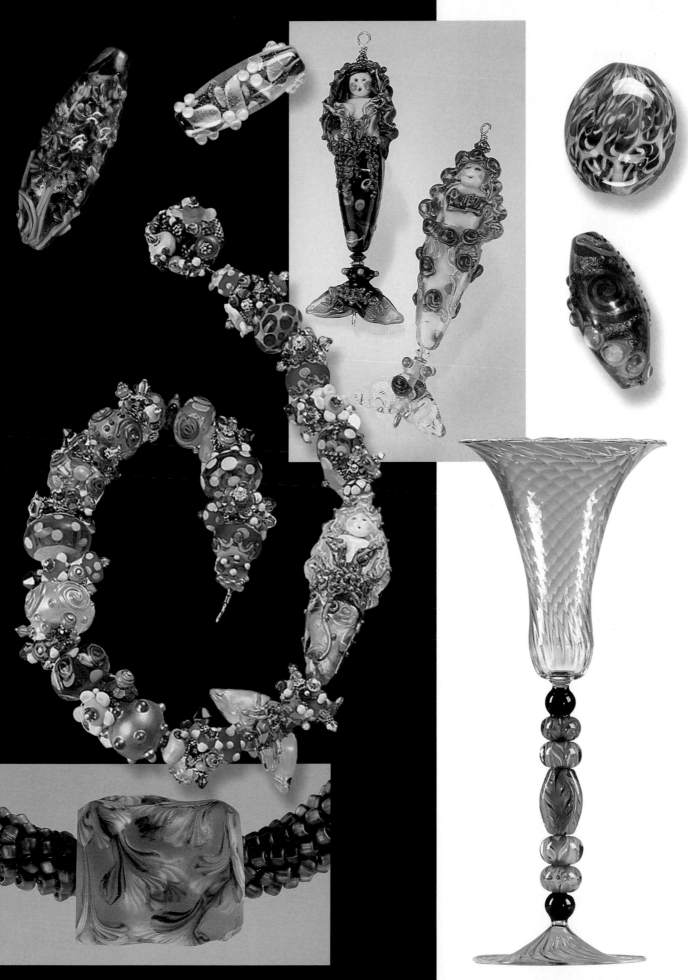

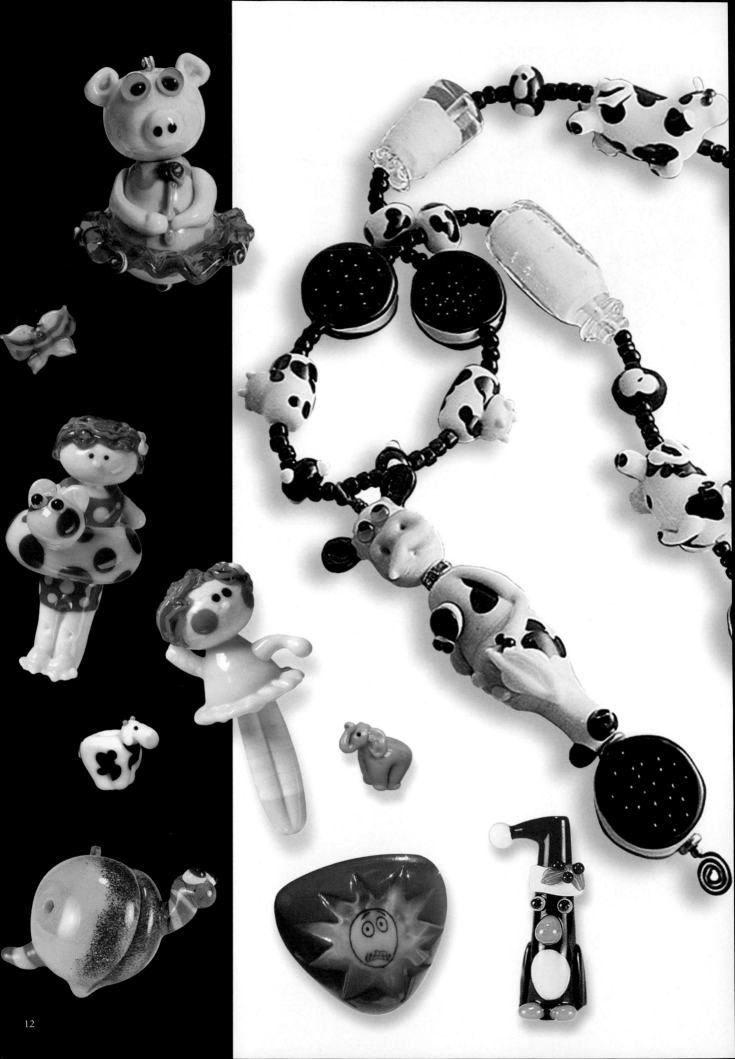

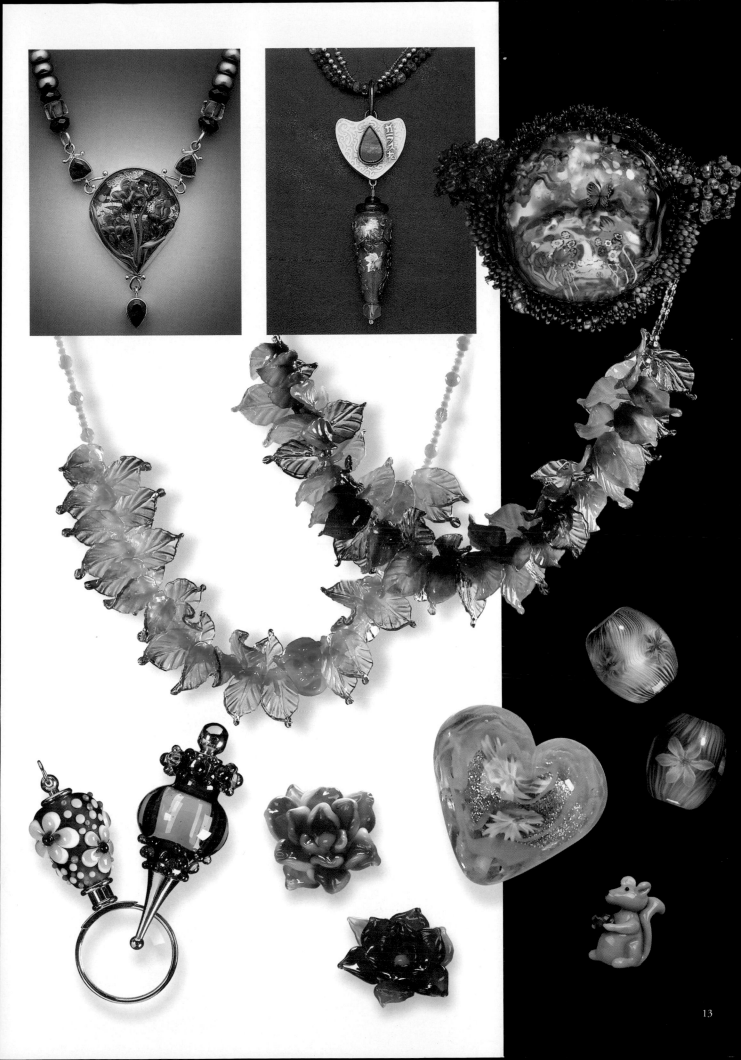

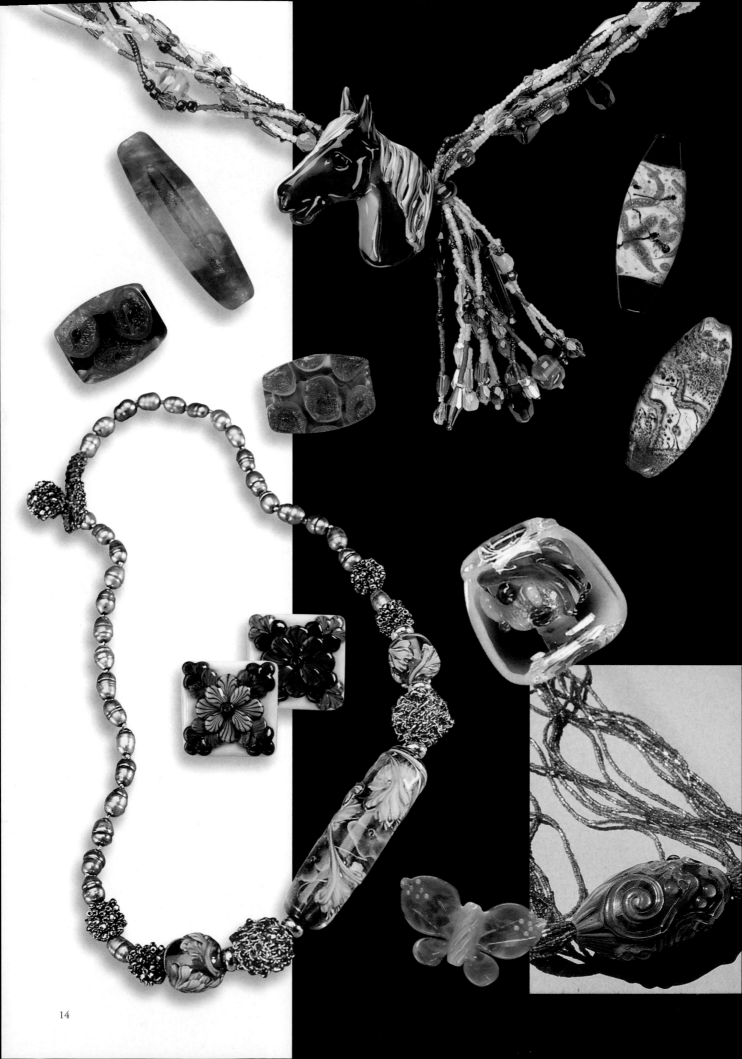

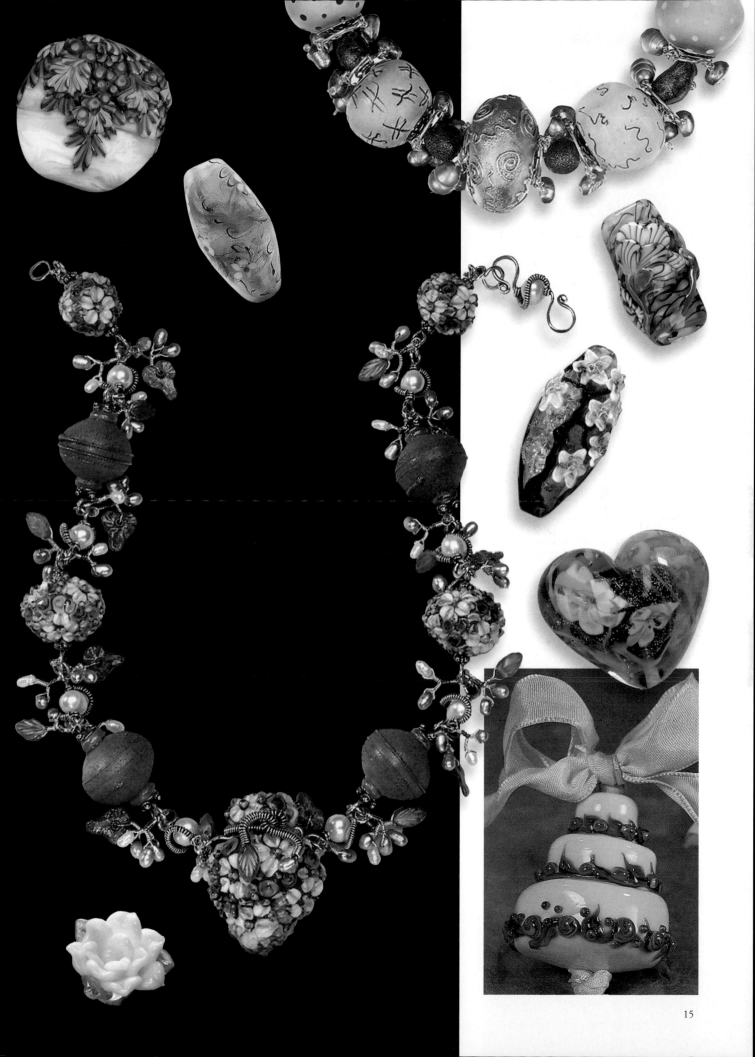

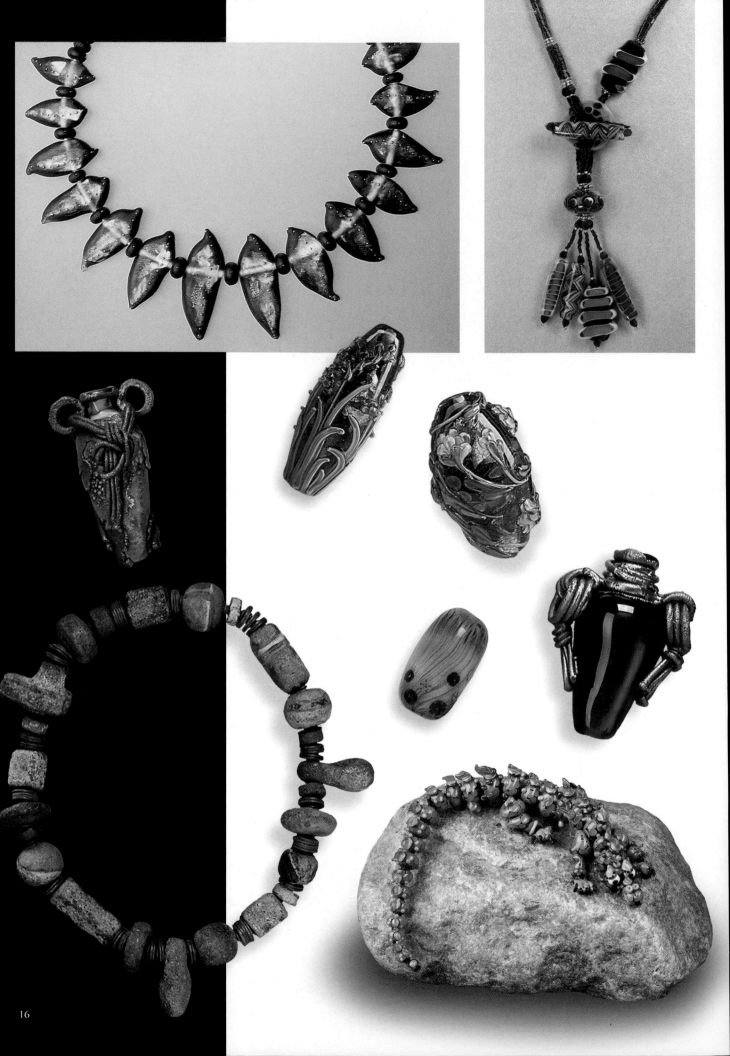

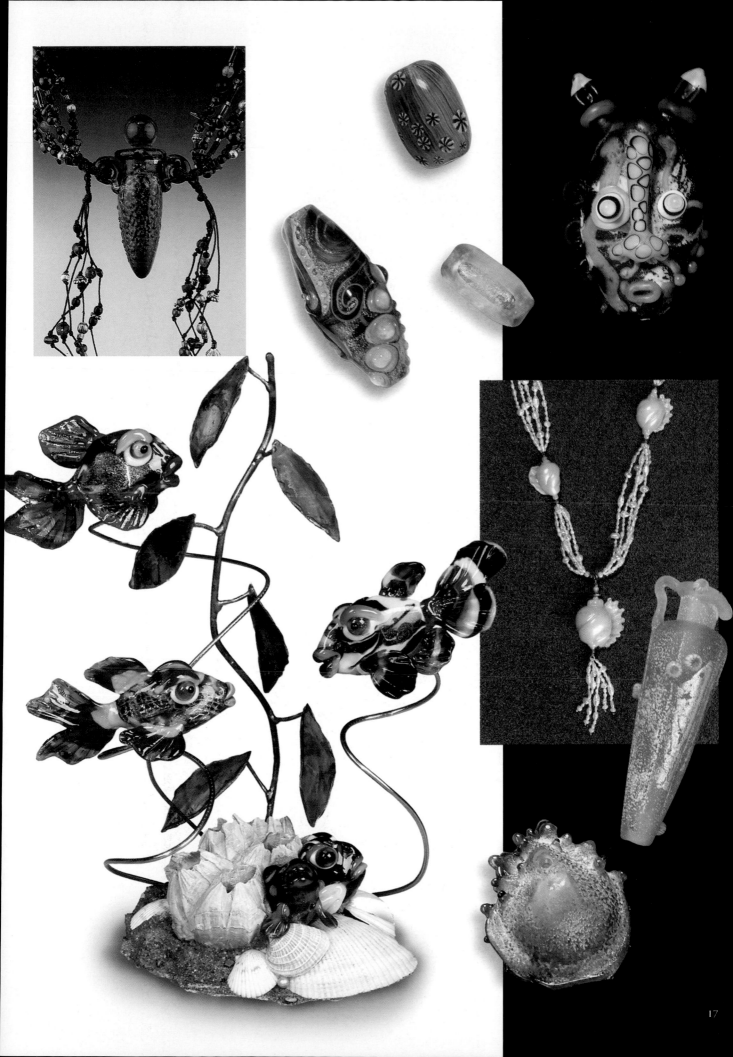

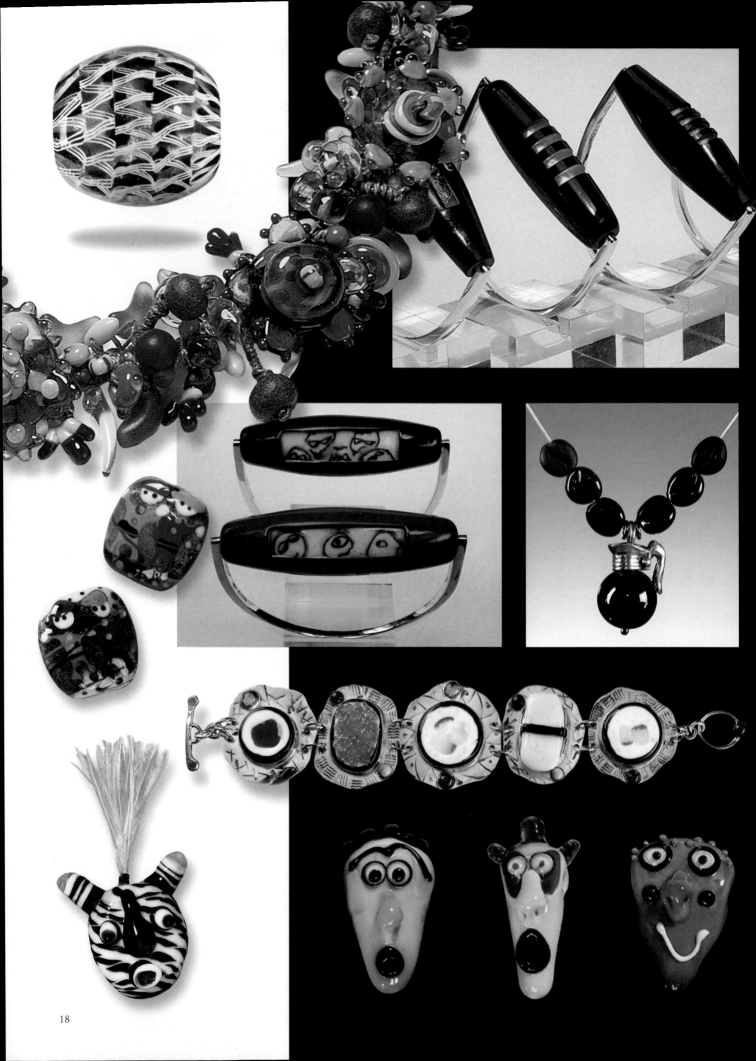

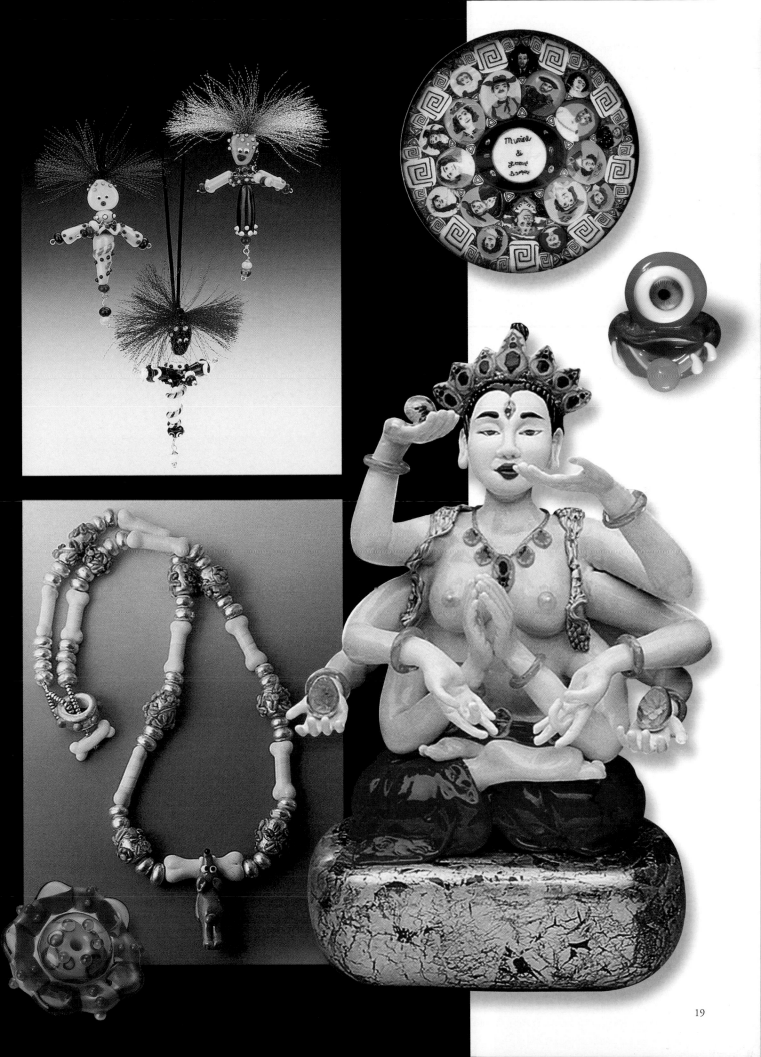

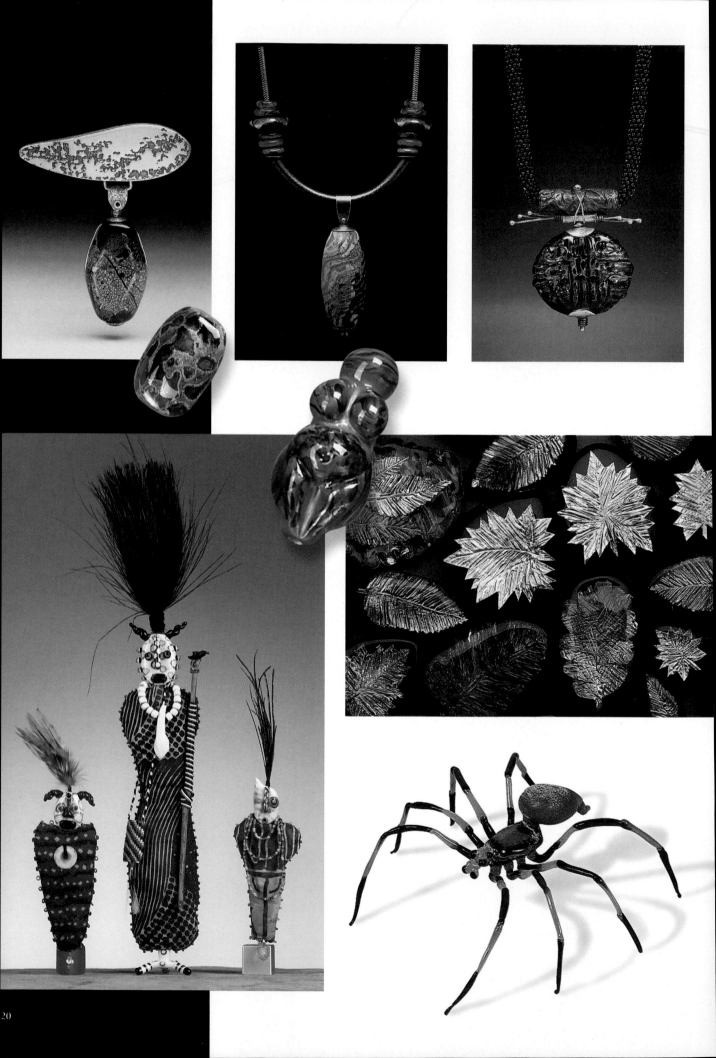

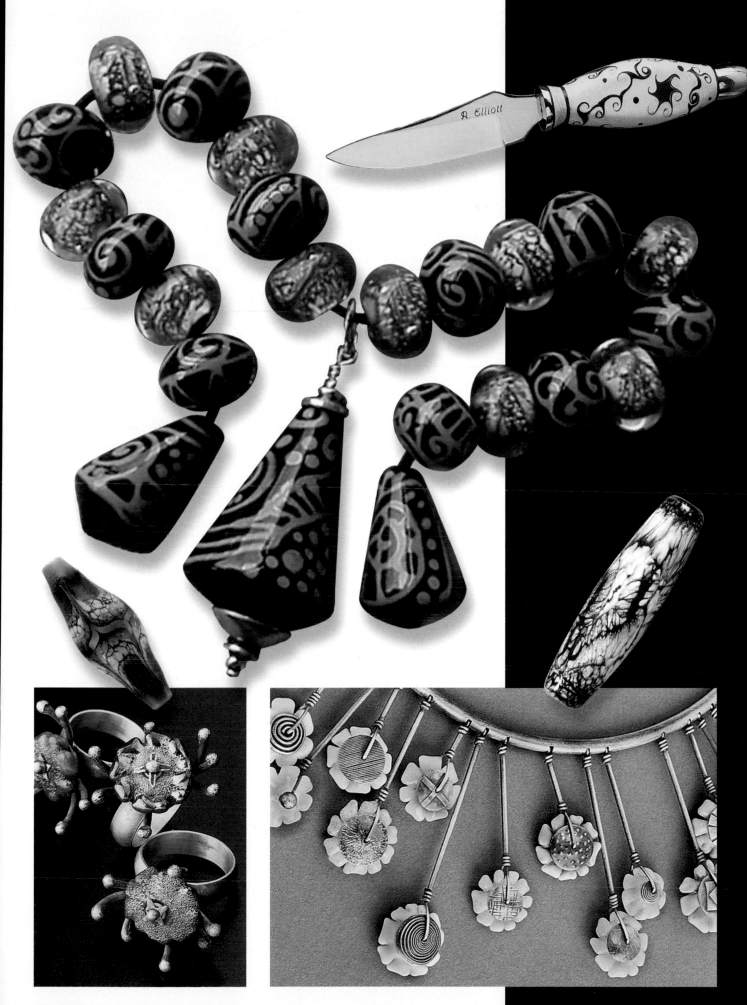

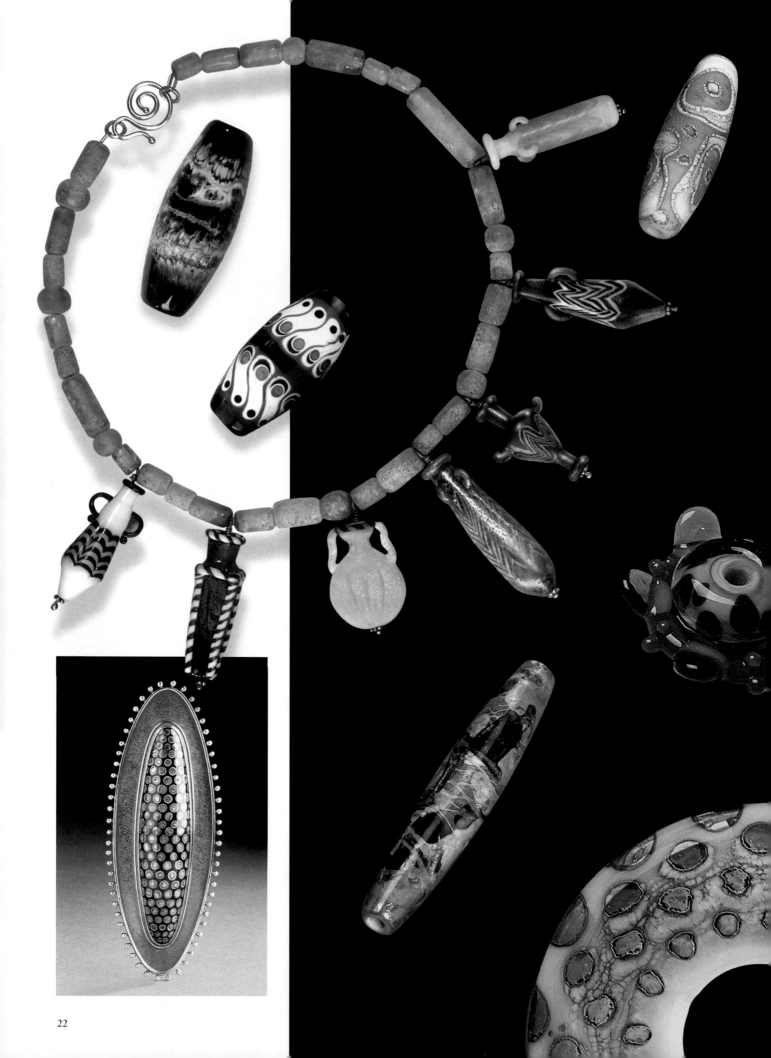

The Artists

The following pages contain short biographies and current work from forty-three outstanding bead artists. Their stories are as varied as the work they create, giving you an insider's grasp of what makes them tick.

Being able to put a face and story with the beads makes them so much more personal and memorable. What fun to take a peek into the lives of so many accomplished beadmakers.

Emiko Sawamoto

Emiko was born and raised in Japan and came to the U.S. in 1983 as a language teacher. During a trip to Italy in 1995 she fell in love with art glass. After trying a few forms of glass work, Emiko found beadmaking to be the most fun. Her first class was only a day long and she felt that she didn't know enough about decorative techniques to make innovative round beads, so her thoughts turned to sculptural beads. Soon she was making teddy bears, Christmas trees and her trademark beckoning cats.

A Japanese influence is apparent in many of Emiko's beads. This includes her cherry blossom, chrysanthemum and temari beads. Temari is an embroidered thread ball, traditional in Japanese craft. Recently she has turned again toward more round beads and less sculpture, but says she has no idea what she will be making ten years from now.

"In not so obvious ways, my Japanese culture drives my desire to create something that is uniquely mine. I believe this is rebelliousness on my part toward my native culture. In Japan, kids are taught to behave the same way as others and are told that 'a nail that sticks up gets hammered down'."

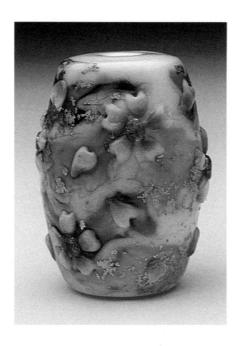

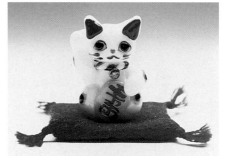

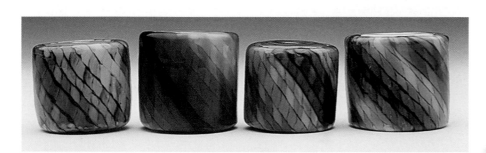

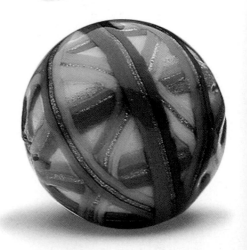

Kristen Frantzen Orr

Kristen earned a degree in journalism and worked for several newspapers after college. She has been a freelance artist since 1976. Explorations in metals and jewelry led her to look for unique beads and eventually to pursue glass beadmaking. She has worked almost exclusively in glass since 1993.

Kristen's handmade glass beads blend her love of nature with her background as a watercolor artist. A single bead can take hours to make, as she draws and sculpts with the molten glass in the flame. To add detail to her work, she makes special canes from multiple colors of glass. By combining these component parts with layers of transparent colors, she creates depth and captures an exciting play of light. After making her beads, Kristen blends them into unique jewelry designs. This process, she says, is like framing a painting, giving the beads a beautiful setting as wearable art.

"I think that with glass I have finally found the perfect medium! I like to use the watercolor technique of layering transparent colors to create depth and draw viewers into my pieces."

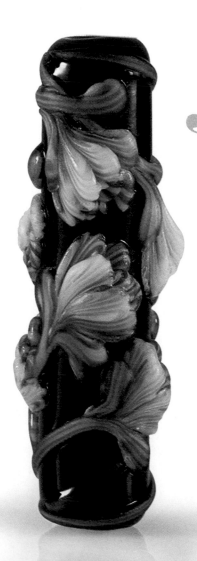

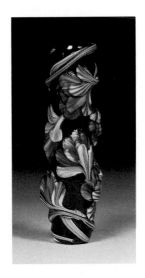

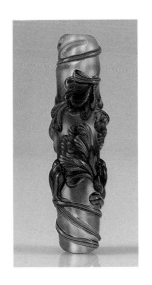

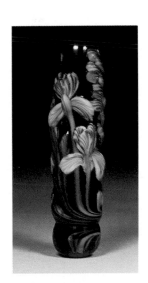

Tom Holland

"I have always viewed fire as a fascinating tool. I first worked with clay and then forged steel which allowed me to learn which temperature did what. I find watching glass go from a slight bend to a soupy fire polish in the flame just delightful."

Tom has been a potter, blacksmith, stonemason and historical interpreter of Living History Museums, among other things. He started randomly collecting glass beads at age 15 as an Explorer Scout. Over the years, he kept slowly collecting. The natural evolution was to start making the objects he was so enchanted with.

Tom started trying to learn the basics of glass beadmaking in 1986. Through phone calls and letters he tried to find someone actively making glass beads. He put thousands of miles on his 1967 Econoline van visiting bead stores, museums and research facilities. He got lots of information but not the nuts and bolts of finding the glass and equipment. Some of the mystery was solved when he met some Pyrex lampworkers at the Texas Renaissance Festival. He learned by trial, error and more research. After attending the first Gathering in 1993, he and his wife Sage fell in love, joined studios and have been partners ever since.

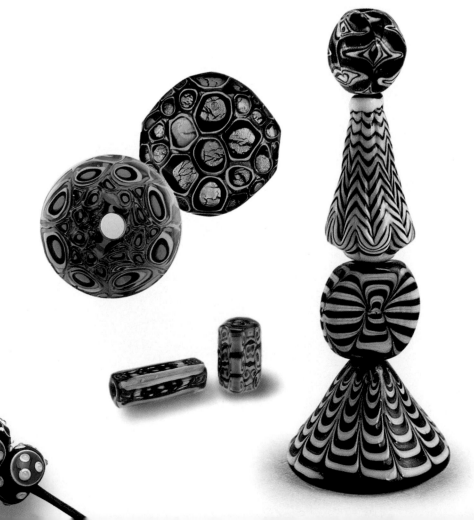

Sage

When Sage was young, her mother kept a small colorful paperweight collection in a low coffee table cabinet. Some of Sage's earliest memories are of hiding behind that table, gazing into the paperweights. Beads became an emphasis early on when her sister gave her an African trade bead. Her sister's explanation of its age and origin captivated Sage's imagination.

In 1988 Sage apprenticed with a local beadmaker to learn the fundamentals of glass beadmaking. In 1990 Sage was recognized for her eye beads at the second International Bead Conference. After attending the first Gathering in 1993, she moved to Arkansas to combine her studio and life with Tom Holland's. They continue to explore their unique brands of beadmaking.

"Being born in Independence Missouri on Independence Day must have made me gravitate towards firework."

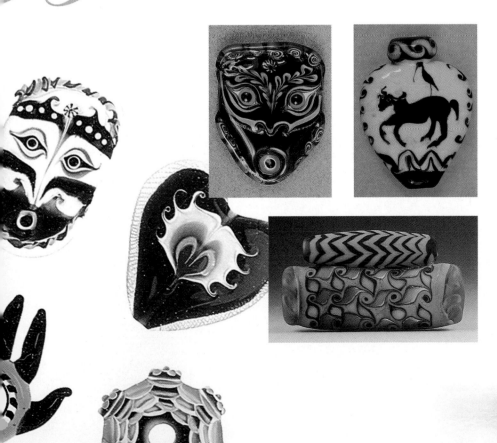

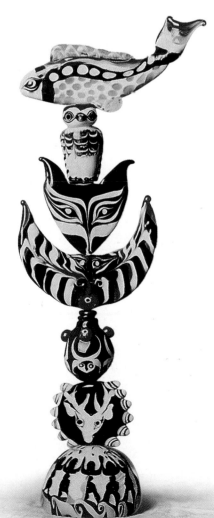

Leah Fairbanks

"I find working with molten glass at the flame seductive and inspiring."

Leah worked with many different types of artistic media before becoming involved in glass bead-making. She explored painting, jewelry design and fabrication, printmaking, fashion design, stained glass, fused and slumped glass and even neon tube bending. After taking her first lampworking class in 1992, her artistic path diverted into the realm of hot glass. Right from the start she drew heavily on nature for her inspiration. She spends a great deal of time traveling and takes time out to observe the local plants and flowers to expand on her repertoire of nature themes.

At the moment, Leah specializes in limited edition beads as well as finished jewelry. She sees herself continuing to push the limits of glass and recently she has begun fusing large blocks of glass, casting and blowing glass. She also does collaborative work in which she forms branches, leaves and flowers in the torch, and then gives them to a glass blower to be attached to blown vessels.

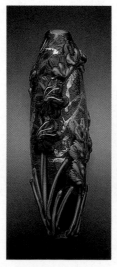

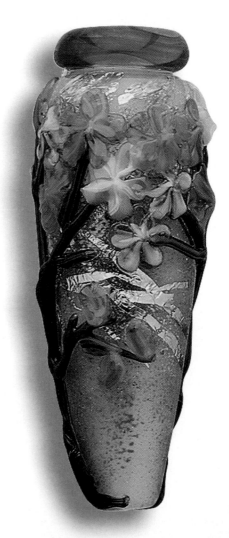

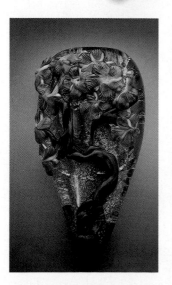

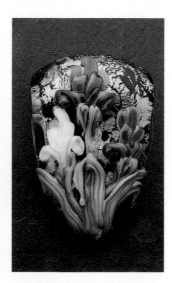

Stevi Belle

Listening to an inner voice, Stevi left a business management career in 1985 to study painting, but then unexpectedly fell in love with glass in 1989. So strong was her draw to glass that she stopped two classes short of a degree in painting to pursue glass blowing. Upon graduation she began to focus entirely on flameworking. Her interaction with other bead artists led her and four other women to organize the first bead Gathering in Prescott, Arizona, in 1993. The Gathering was the spark that was soon to create the Society of Glass Beadmakers.

Stevi is passionate about the entire process of flameworking: the solitary nature of the work, the infinite opportunity for play – with color, texture, form and shape – and the unlimited potential that glass continues to offer. Having explored many different creative media, Stevi feels that glass and fire are her soul mates in the world of artistic expression.

"I experience glass as both clear and mysterious, fluid and solid, hot and cold, giving and unforgiving, fragile and durable, always capable of surprise."

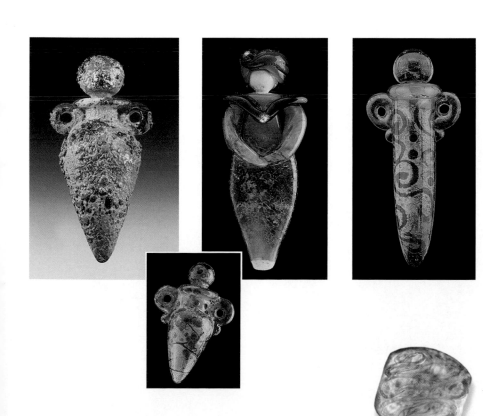

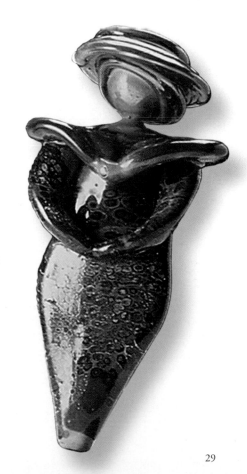

Beth Williams

Beth has been making glass beads since 1993, ever since she found out that it was possible. While working as a metalsmith and jeweler for 10 years, she was always searching for a way to bring more color into her work. Making her own glass beads did exactly that, giving her more design freedom and allowing experimentation without the expense of using precious gems.

Beth likes combining glass with various forms and kinds of metals. Her signature technique is adding 24-karat gold granules to the surface of a richly colored, multi-layered bead, which is often acid etched to create a soft tactile finish. She feels that the judicious addition of metals can create a completely new palette with which to work. Metallic accents on the surface can also create finishes and textures that are not available with glass alone.

"Gardening is my passion and inspiration. I love how colors interplay in nature in ways we might never think of ourselves."

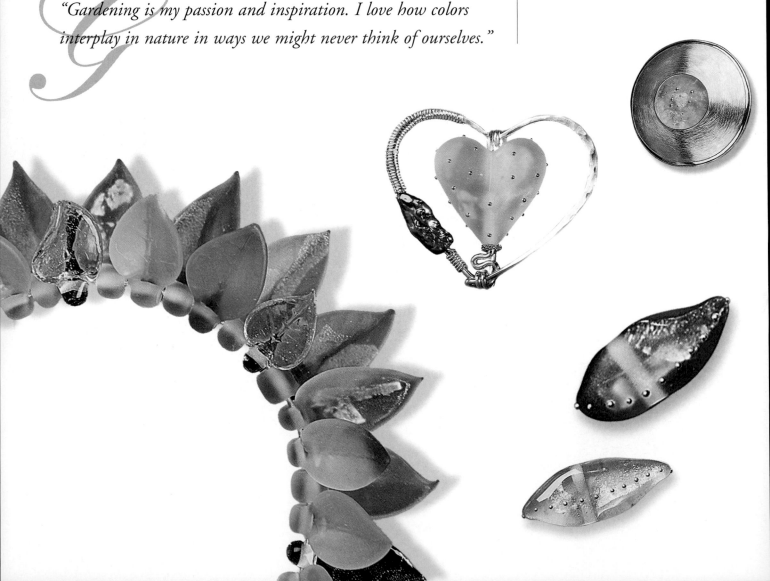

Kristina Logan

Although Kristina has a BFA in sculpture, she is recognized internationally for her glass beads. Her beads, jewelry and objects have been shown in galleries and museums all over the world.

Kristina believes in making things from the heart and to the best of her ability. Being an artist is the way that she looks at life; it's her day-to-day view of all things and experiences. Her work as a glass beadmaker is part individual expression and part connection to ancient cultures and artistic traditions. Because of her own sincere desire to create, Kristina also makes time to teach. She hopes that the students will take the information she gives them and "fly with it", taking what they feel is important and creating something new. Kristina has taught students throughout the United States as well as Italy and France.

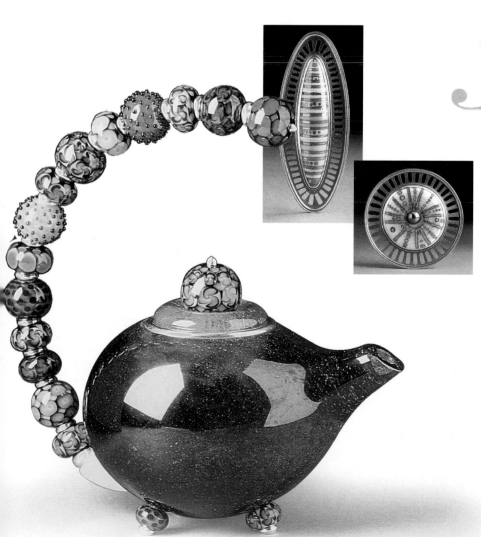

"I feel there is something deeply spiritual about an object that is made by hand and worn next to the skin. Glass beads form a historical thread, connecting people and cultures throughout history. I am humbled by the thought that my beads, and my student's beads, may have meaning to people long after we are gone."

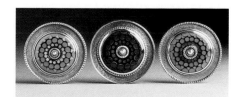

Pam Dugger

Pam began making jewelry in 1983. After learning wire wrapping, she taught classes at a local shop. Soon she was fusing glass pieces for her jewelry, but found it a bit limiting since there was always a flat side. She heard that you could make a round bead with a torch by winding glass on a wire. This set her off on an odyssey of much experimentation and many torches.

Pam says that most of her beadmaking knowledge has come from trial and error. She took glass blowing classes but found the solitude of beadmaking more to her liking. Even so, a lot of the blowing techniques transferred over to her beadmaking.

At the present time, Pam is concentrating on fish and fowl designs. This stems from years of scuba diving, her numerous salt water aquariums and the colorful parrots that fly over her back yard.

"I hope that when a person owns one of my beads it will make them think about the environment, about love and protection of nature and our natural resources."

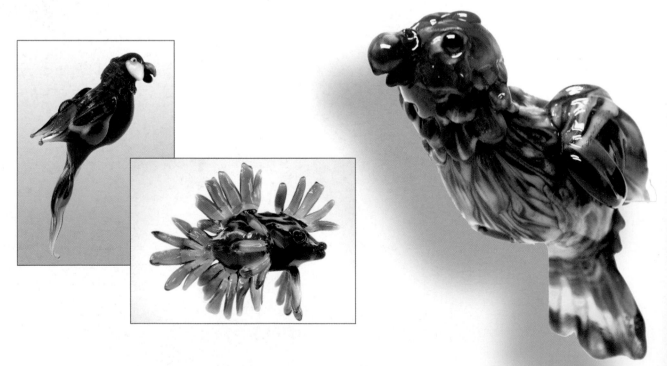

Sharon Peters

Sharon has been drawing since she was a kid and many of her early beads were attempts to capture those drawings in glass. More recently, she has been inspired by doodles, puns and the wackier bits of popular culture.

Sharon has a degree in Studio Art. She designed and built stained glass windows in her spare time for 20 years while working full time in data processing. She made her first bead in 1996 and at last found her art form. Sharon says she has never had more fun in her life than in that beginning bead class. Since then she has worked like crazy to develop a personal style and it's obvious she has succeeded. Sharon recently quit her job to work with glass full time. Needless to say, her beads have brought a lot of laughter and delight to the bead world.

"Most of my bead designs are bright and goofy because I like them that way."

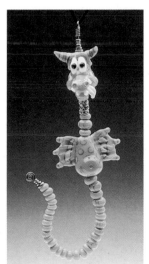
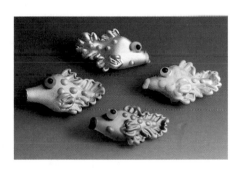

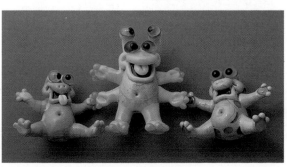
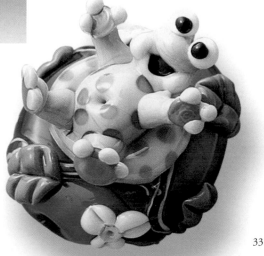

Lani Ching

"Philosophically, I am inspired to contribute things to society that make people smile. Beads can do this."

In the early 1990s, Lani saw a bead-making demonstration during a glass fusing class. She immediately signed up for the next beginning beadmaking class. Lani began making beads from strips cut from sheet glass and continues to do so today. Her first big break came when a large sheet glass company purchased 30 necklaces from her. The necklaces contained beads made with their glass, and were given away to their customers worldwide. This recognition was a major source of encouragement.

Beadmaking is Lani's creative outlet from her day job as a clinical pharmacist. Working at the flame allows her to be alone and to ponder. The bead culture also links her to entertaining people she might not otherwise be exposed to.

Lani's inspiration comes from multiple sources, often by extracting small elements from larger pieces of art. Color ideas come from plants, textiles and fashion trends. Lani prefers abstract design in most of her beads so that each individual bead will contribute to the whole in a finished jewelry piece.

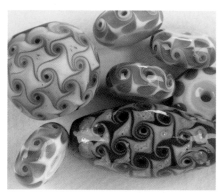

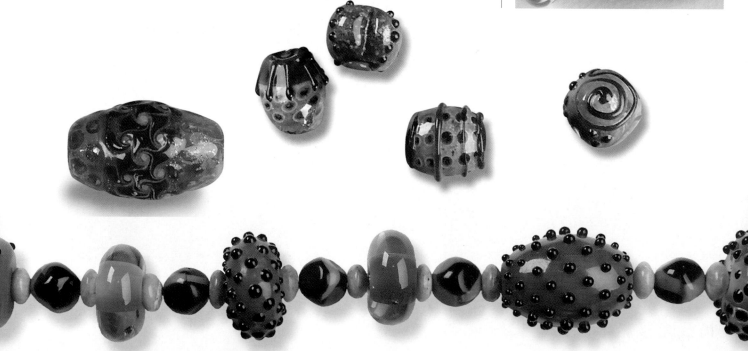

James Allen Jones

James began making beads in 1987 after graduating with a degree in sculpture. After seeing pictures of Japanese lampworker Kyoyo Asao's beautiful mosaic beads, he became obsessed with the idea of making them. There were no other glass beadmakers in Oregon at the time and very little information was available. James spent several months just developing a usable bead release. For a while, he just had bouquets of beads stuck on their mandrels. One of his first beads was made with several incompatible glasses all in one bead.

After taking a fusing class, James finally was able to figure out how to make mosaic pattern bundles for his beads. He used a homemade glory hole powered with a hair dryer to stretch out the pattern cane. His signature technique is building murrini with a hole in the center for use as bead end caps.

"After 14 years of beadmaking, I feel fortunate to have been part of the revitalization of a dormant craft that occurred here in America. I am grateful to be taking part in the evolution of the new tradition of beadmaking."

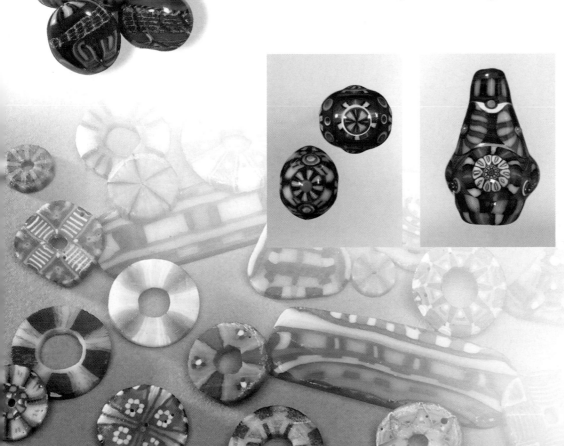

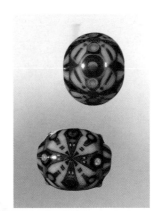

Stephanie Sersich

Imagine growing up in Stephanie's house, where there was always a ribbon drawer, a tissue paper drawer and another drawer filled with feathers, glitter and sea glass. Her mother makes wild costumes, ritual instruments and ceremonial objects. Because of this, Stephanie learned early to sew and to love color. In addition, she developed a variety of stringing and knotting techniques that allowed her to bind beads and small treasures together.

While in college, Stephanie started to make her own glass beads to use in her already unique jewelry. This jewelry consists of a blend of beads, natural materials and collected objects from all over the world. Even though her artwork takes the form of jewelry, she thinks of it as creating talismanic objects and often makes lampwork beads with a specific jewelry design in mind. Stephanie's favorite technique is manipulating dots using a stringer as a combing tool to create "arms" for stars, flowers and other designs.

"My motto is: You can make anything from a dot."

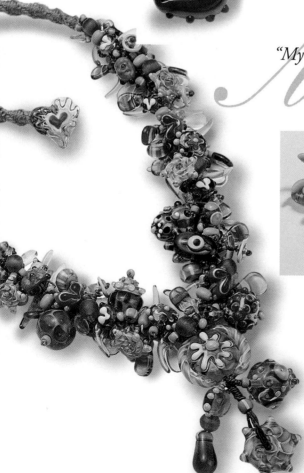

Jessica Bohus

When Jessica graduated from high school, her mom enrolled her in a week-long summer arts program in Michigan. She fell in love with the place and since that first week has spent part of every summer there. Because of this, Jessica was exposed to glass in many forms over the years and eventually got what a friend refers to as "glassy-eyed". When she sees the hard cold surface of the glass become soft, hot and flexible, her eyes get a glow.

Working so much in glass, it was inevitable that she would be exposed to lampworking. After her first day in a beadmaking class, she bought a torch and has been making beads ever since. Jessica now lives in an 1880's two-room school house which also serves as a gallery and studio space, not far from where she spent that first summer week. She has come full circle and now goes there every summer as a teacher instead of as a student.

"I love my life. Creating neat-o objects, sharing with other artists and students is all a dream come true. I wouldn't change a thing."

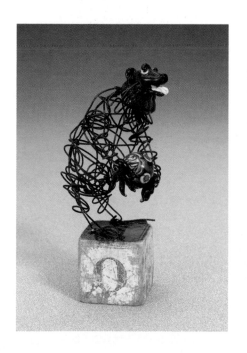

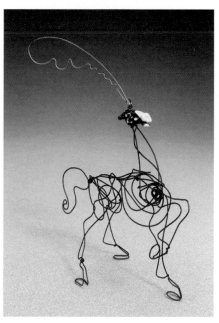

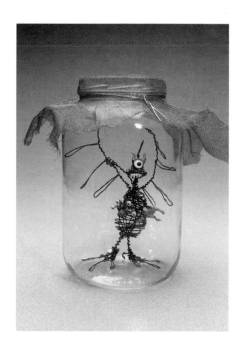

Lisa St. Martin

During her sophomore year in college, Lisa saw an ad for a glass blowing apprenticeship in Corning, NY. She found it a most amazing, enlightening and exhausting experience. Since Corning is such a glass center, she was able to study at the museum and library, learn wheel engraving from Steuben's leading engravers and meet a lot of soon-to-be-famous glass blowers.

After moving to Dayton, OH and taking lampworking classes, Lisa attended the very first Gathering in Prescott, AZ. She now works simply, with her torch and a few tools. She pours her extravagance into the glass she uses, including a lot of dichroic glass. Lisa has been teaching beadmaking to adults for several years but really enjoys working with children. The child outreach program she teaches combines the physics and chemistry of glass with the "gee whiz – that's so cool" aspect of the torch.

"I worked on my Masters in Glass Technology at the University of Kansas. It was a lot of fun walking across the prairie to the old stone barn studio with my blowing iron over my shoulder. There were buffalo in that field – big buffalo."

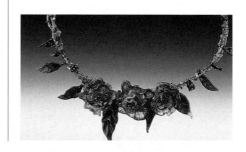

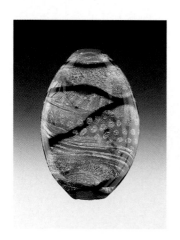

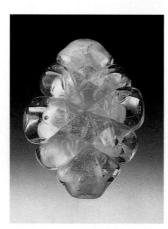

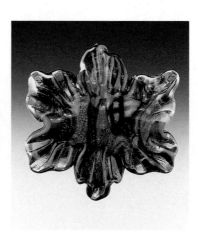

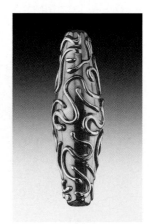

Alethia Donathan

Alethia fell in love with beads at first sight and together with her mother, opened up a bead store in downtown Honolulu in 1992. Purchasing inventory for the store required extensive travel and this exposed her to the wonderful world of handmade glass beads.

Alethia took her first lampworking class in 1995. She followed that up with additional classes from some of the best beadmakers around, and this has allowed her to fine-tune her craft. Many of her beads are inspired by the textures, colors, natural beauty and mystique of the islands. By combining her own blends of frits, enamels and mixed metals, she is able to capture the look of sand or the image of a hot lava flow.

An avid Harley rider, Alethia occasionally takes time out to ride around the island to feel the wind in her face while experiencing the sights and sounds of the island.

"As a full time lampworker for the past six years, lampworking has become both work and play, the process and final product, a passion and an obsession."

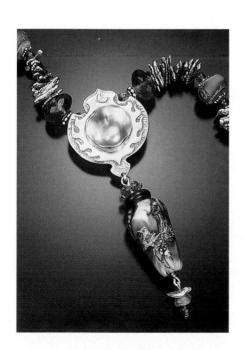

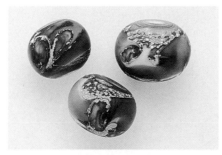

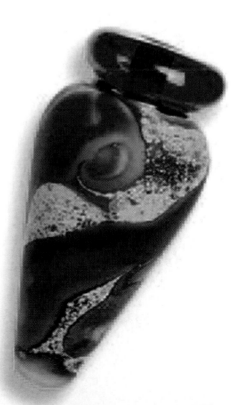

Nicole Zumkeller *and* Eric Seydoux

Nicole is a professional dancer who founded her own dance studio in 1990. Eric is a professional painter and illustrator. He now works full time with beadmaking. Nicole and Eric live at the foot of the Alps and spend most of their free time walking in nature. They frequently travel to Asia and North America and have been long time collectors of trade beads. They started glass beadmaking by chance after meeting with the pioneers of the American glass bead movement. Soon after, they returned to Europe to pursue beadmaking thinking it would not be a problem. After all, "Don't all these lampworked glass beads come from Europe?" They quickly found out that nobody knew what they were talking about. They now return to the United States every year to learn more. Considering the great distances Eric and Nicole have traveled to pursue their dream, they find it humorous when a student from only 50 miles away will ask if there isn't a class closer to them.

"We teach in both Switzerland and France, and our students come from European countries all around. It is not unusual for us to be teaching in three different languages in the same class".

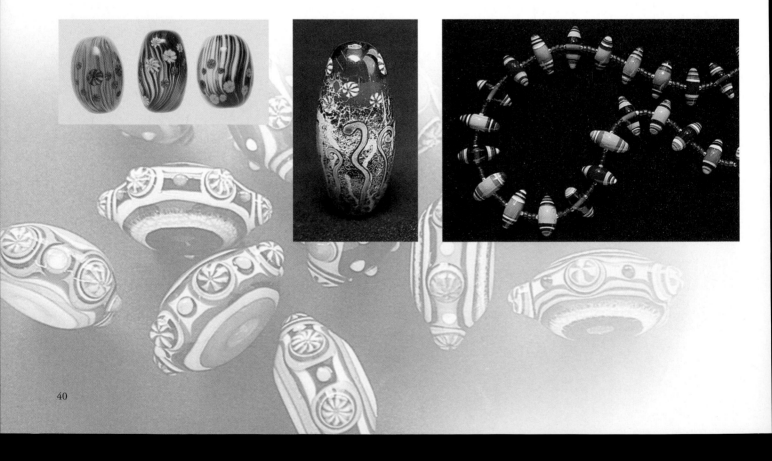

Kimberly Jo Affleck

Kim has always been attracted to the flame. At the age of 12 or 13, her mother took her to a glass blowing studio to watch. The artist was making huge bottles and vases out of beautiful aquamarine glass. Kim remembers loving the sounds, smells, flames and rolling heat in that studio. To her it seemed like heaven.

When she was young, her parents were very concerned with what was "lady like" and playing with fire definitely didn't qualify. Her artistic abilities were directed instead into painting, ceramics and music. Kim's degree in Fish Biology and Environmental Studies was a far cry from art, so she pursued knitting and weaving on the side. She was able to find great inspiration in the colors and textures of threads and yarns.

In 1998 Kim and her then 13 year old son went to watch a glass bead-making demonstration at a bead shop. They were immediately attracted and signed up for a class. From that day on, both of their lives changed. They now make beads as often as possible.

"Most of my color ideas come from the glass itself. When I look at my cardboard tubes filled with all the colors of the rainbow, ideas come so fast I can't capture them all."

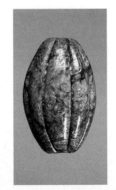
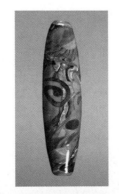
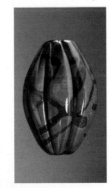
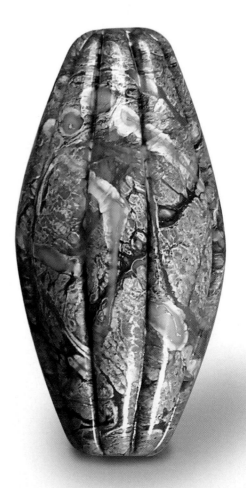
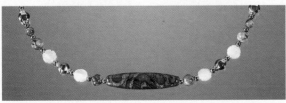

Janice Peacock

Among the unusual jobs Janice has held are disc jockey, radio announcer and even working in the costume department at Disneyland. She ultimately ended up with a career as an educator and writer for the software industry. Although she loved working in a high-tech field, she found that she also needed a way to express herself creatively. This need led Janice to take classes in stained glass and fusing, but she did not like the two dimensional aspects of the work. Next, she tried polymer clay but missed the weight and transparency of glass beads.

After making a bracelet full of fancy glass beads that turned out beautifully, she still felt frustrated that she hadn't been able to find the perfect beads. At this point, the thought came to her that *someone* had made these beads. Janice became obsessed with finding out how to make glass beads. Although information was scarce in 1992, she managed to find a workshop and has never looked back.

"I realized that if I could learn to make my own glass beads, I could have the exact beads I wanted, not just what the store happened to have."

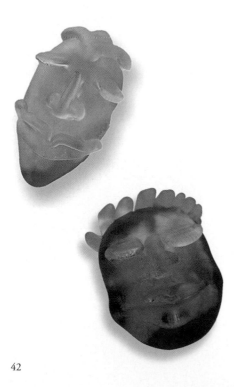

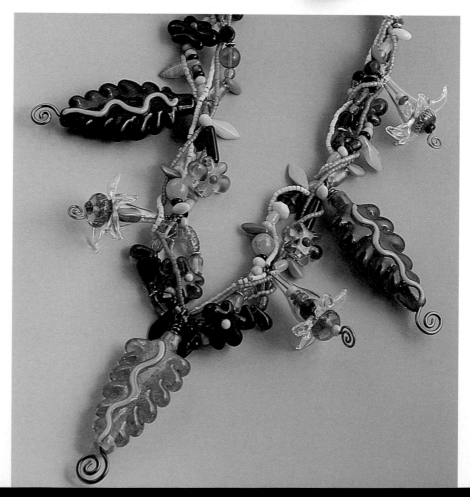

Mary Gaumond

Mary has a BFA and works as a display artist for a department store. She has a lot of fun being creative at work and enjoys the folks she works with. Her first exposure to lampworking was in 1994 while taking a workshop in fused glass. There was also a torch class going on and a friend pulled her in to see it. Mary found it fascinating but felt she was there to learn to fuse, not lampwork.

In 1996 Mary finally signed up for a lampworking class. Even though she thought she was terrible at making beads, she became good friends with the teacher and quickly set up a studio in her home. After taking a two-week course in murrini making, there was no turning back. Mary still doesn't feel confident making beads at the torch, so she concentrates on canes, buttons and cabochons. On the weekends, and before going to work in the morning, you can find Mary in her glass studio concocting new things.

"When I finally convert my garage into a studio, I'll no longer have two kilns as bed stands! I will be able to continue my journey in hot glass, combining fusing techniques, torchwork and an active imagination."

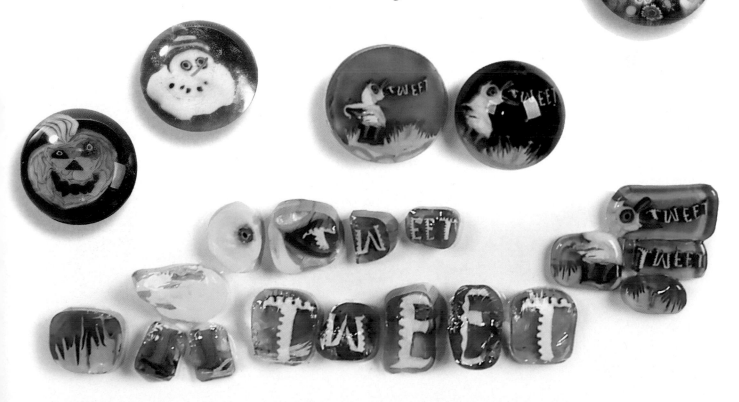

43

Barbara Becker Simon

Barbara has always known that she wanted to be an artist and has therefore never pursued any other career. She received an MFA in silversmithing and has worked in metals making jewelry for thirty years.

Barbara claims it was crazy the way her passion for glass beads got started. As a metalworker, she was involved in organizing seminars for the Florida Society of Goldsmiths. In 1996, her local chapter decided to host a daylong glass beadmaking seminar. Because it was held in Barbara's own garage, she was invited to sit in. She says she had little interest at first, thinking that there was no reason for her to learn the craft since she didn't use beads in her work. That all changed when she made her first bead. An epiphany occurred and she thought to herself "wait a second here – *this is it!*" Since that time, Barbara has been consumed with a passion for glass and its infinite possibilities.

"The marriage between my glass work and my metal work is evolving in very exciting ways! Stay tuned..."

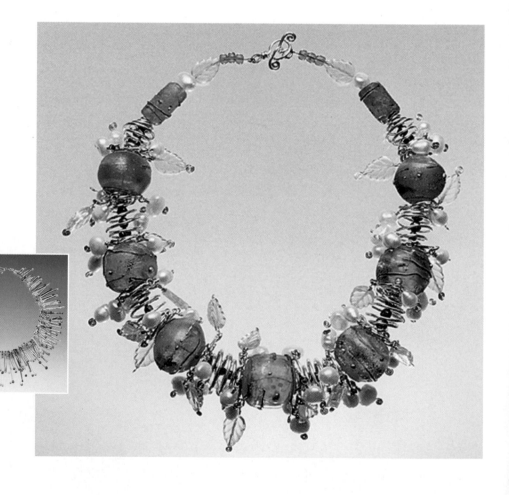

Ofilia Cinta

Ofilia was born in Chicago, IL, the child of Mexican immigrants. She had the good fortune to be raised in two cultures. Her heritage was reinforced by yearly trips to Mexico. Her relatives took her on countless road trips to sites including ruins, pyramids, monasteries and mummies. She saw open air-markets, indigenous arts and crafts, jungles, deserts and endless coastlines. The spicy culture of Mexico enhanced these experiences and profoundly impacted her eye for color.

Ofilia's introduction to lampworking came about when she met a local beadmaker. Since that time she has taken numerous classes and works at the torch as much as she can. Lampwork has allowed her to "paint" in 2-D with the end result being 3-D.

"My favorite forms of color application are the four S's: spot, stain, smear and scribble. I cannot use color straight out of the box. I love to blend and overlay the colors."

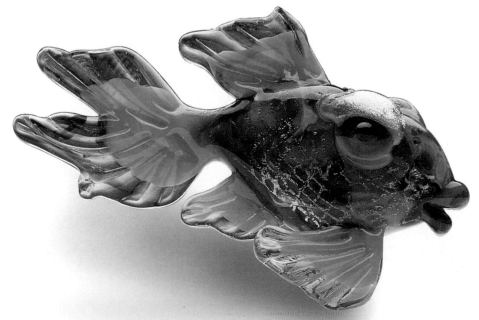

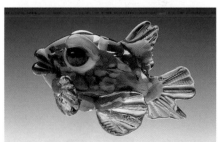

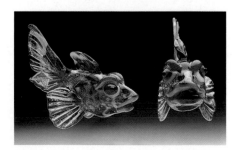

Nancy Pilgrim

Nancy's first creative endeavor began in 1984 when she learned to do calligraphy. To this day she continues to teach calligraphy at the local community college and finds that a lot of the skills have transferred to her glass beadmaking.

Nancy started making glass beads in 1995 after seeing a demonstration at the gem and mineral show in Tucson. She and her sister, Linda Burnette, made beads whenever they had a spare moment. After about a year or so they started meeting other beadmakers in their area and learning about different tools and equipment. It wasn't long before they had to start selling beads to support their habit.

Nancy feels that numerous workshops taken over the years have influenced her bead designs. She is also inspired by nature. Nancy loves the colors and images of tropical locations and finds that her travel experiences creep into her choices when working with glass.

"In 1996, Lapidary Journal called and asked me and my sister Linda to submit slides of our beads. One of those slides ended up on the cover!"

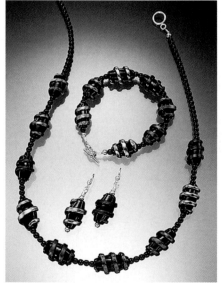
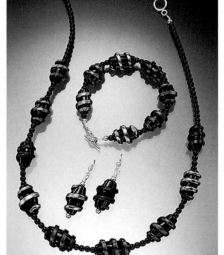

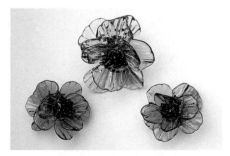

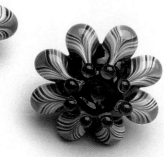

Heather Trimlett

Heather never thought that a birthday present would change her life, but in 1992 a glass beadmaking class opened up a brand new chapter in her art glass career.

Heather likes to make small beads with eye-popping colors and a lot of contrast. Some say that her beads look good enough to eat. She doesn't recommend it, but loves the compliment.

Years of fascination with ancient glass inspired Heather to create her own version of a Greek amphora (vessel).

Sometimes her imagination controls the design and other times she goes with what the glass wants to do. Her favorite vessels seem to resemble ladies standing proudly with their hands on their hips.

One way that Heather gets her inspiration is working in the garden. This gives her more time to play with color, puts a smile on her face and gets dirt under her fingernails.

"I'm not a Zen sort of person, but beadmaking is a very Zen experience. It takes me to a place where everything in the world is blocked out, leaving only me, the glass and fire – it's magic."

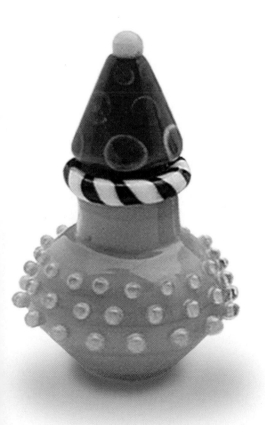

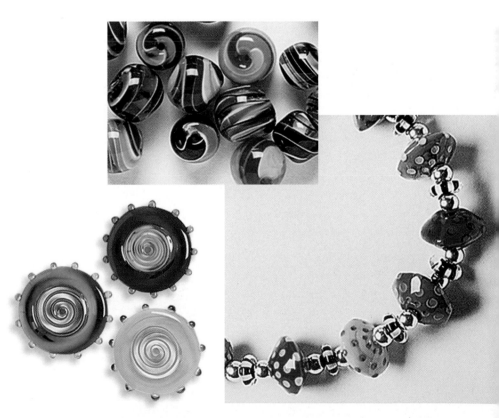

Beau

Beau Justin Scanlon Anderson was born at home in Bellingham, WA. Because both his parents are artists, he had early exposure to working with his hands. He became interested in glass beads when his mother started making them in 1987. He had played with stained and fused glass but thought that making beads was a whole lot more fun.

Beau has traveled extensively and during his travels has found beads to be his preferred currency. Beau's philosophy is that we have little time on earth and leaving behind some beads would be a small symbol of the deep appreciation he has for life. He hopes that his beads last a long time and that throughout their journeys they will spark an appreciation for life in those whose paths they cross.

"Through good will, creativity and efficient hard work, I thrive."

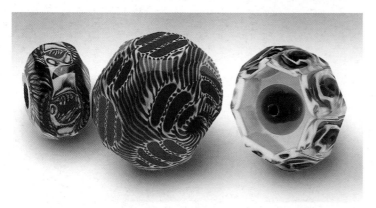
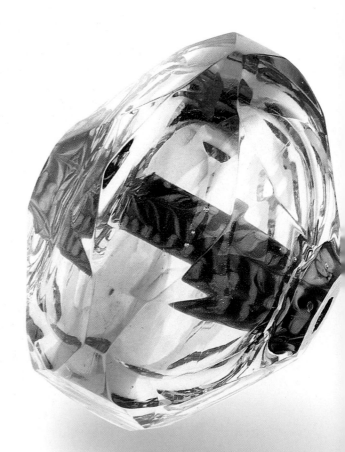

Isis Ray

Isis received a degree in Fiber Art in 1985. She has been self-employed since 1981 as an artist/craftsperson designing and making banners, hand painted clothing, jewelry and finally making glass beads starting in February of 1992. She now spends a lot of time creating complex murrine for her beautiful beads. Her current work is a series of beads inspired by rainforests with the hope of capturing some of the wilderness as a talisman for the future. Isis also loves the wild painted faces from tribal cultures, and is working on transforming these images into glass murrine.

Isis says that in order to make successful murrine she tries to make only what she needs of each component and, most importantly, keep the individual components small. If your parts are all the right size when you create your final bundle, there is actually very little pulling involved. The bundle sort of lengthens by itself when it's evenly hot. This lengthening process miniaturizes the picture in the cane.

"I'm inspired by the ancient glass artists who created murrine of astonishing complexity two thousand years ago, as well as the 19th century Italian murrine artist Giacomo Franchini. Ten years from now I will probably still be trying to be as good as they were."

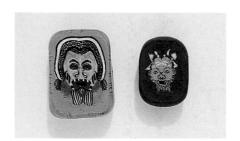

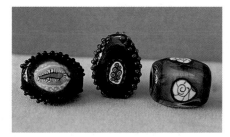

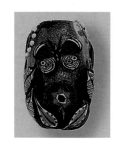

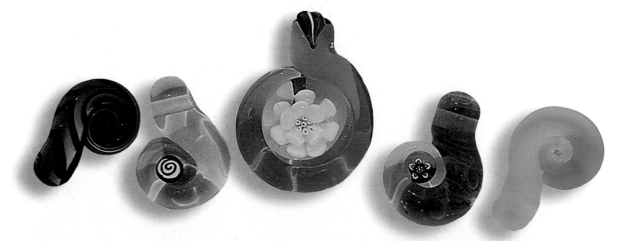

Budd Mellichamp

Budd has had many jobs in art related fields. At one time he was designing and building decks and greenhouses for orchid enthusiasts and had a personal collection of over 750 plants. He began making beads in December of 1993 after his family gave his brother-in-law a beadmaking kit for Christmas. His brother-in-law was so excited that he brought it over the next day and let them all try it out. Budd immediately ordered the same kit for himself. The green house became a studio, most of the orchids were given away and Budd became a full time beadmaker.

Budd is most well-known for his *gizmos*. These labor-intensive one-of-a-kind patterns are individually lampworked on the end of a glass rod and then applied to the bead. Glass stringers are used to build up many layers of overlapping colored dots. Gizmos can have up to 256 separate dots; each gizmo takes 15-30 minutes to make. Several of these gizmos are incorporated into a single bead, creating a visual feast.

"In 1995 I heard about the Society of Glass Beadmakers. Imagine my amazement to find out that there was a whole society dedicated to this art form."

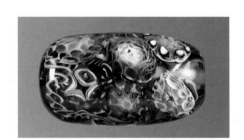

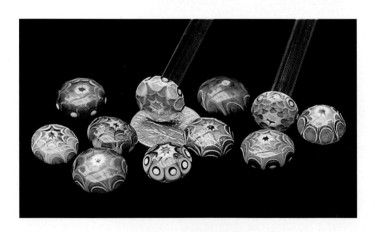

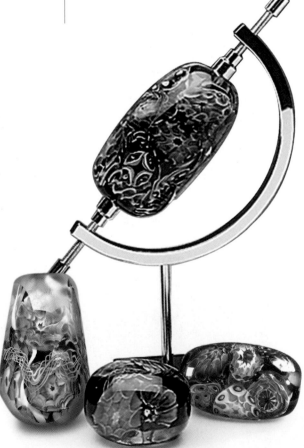

Pati Walton

Twenty-four years ago, Pati learned to do stained glass. She soon found plain flat glass boring and quickly moved on to 3-D work like boxes and complex kaleidoscopes. She actually made her first bead in 1979 but never made another one until 1992. At that time, her sister was living in Venice and looking for a certain color bead for her jewelry making. Pati told her that she could probably make it.

Trying to create that bead for her sister got Pati addicted. Before long she set up a rough studio in her garage. She loves living in the mountains and has become obsessed with creating little scenes in her beads. Animals, plants, waterfalls, rocks and trees are inspirations that continue today. Pati confesses to making lots of mistakes along the way and says she is still learning on a daily basis.

"When I'm riding in my car and see a landscape I like, I try to imagine how it would look in a bead."

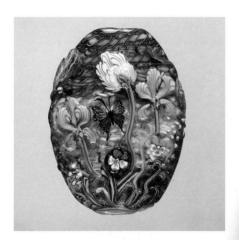

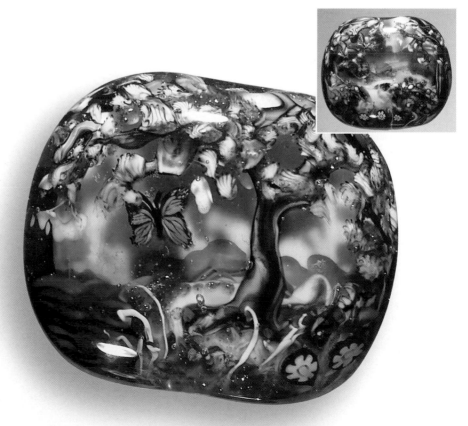

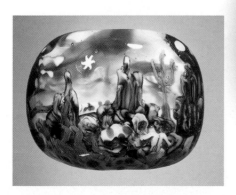

René Roberts

René began playing with glass in 1978 while working as a criminal trial lawyer. She would get up at 4:00 in the morning to cut glass in order to be at a trial beginning at 8:00 a.m. A couple of years later she took a break from the courtroom, joined a couple of cooperative art galleries and never returned to law practice. René started working her glass in a kiln in 1980. It wasn't long before she was trying to alter the color and textural quality of the glass while it was molten.

In 1987 a glassworker friend gave René a ten-minute basic beadmaking demo and then drove off into the sunset, leaving her wondering what to do with this new (and seemingly frivolous) bit of knowledge. For a while, she just made beads the size of peas to use in her own jewelry. Then René discovered that people didn't necessarily want the jewelry, they wanted the loose beads! She finally relented and this kept her experimenting and developing her torch skills. She still doesn't consider herself a beadmaker but views beads as just one aspect of her artistic focus.

"While I love all the qualities about glass which are seductive – the bright color, the transparency, the fluid way of working – what has always excited me the most is how glass can be altered in an organic textural way, and can be colored and transformed by metals and earth materials. It is like returning the glass to its source."

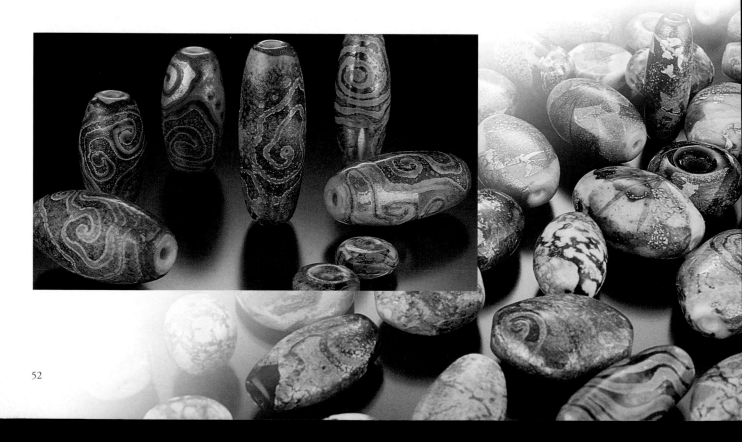

Larry Scott

In 1991, Larry left his job as vice president of sales and marketing at a Seattle paper box company because he just couldn't stand it anymore. In 1993 he made his first bead. In the intervening years he has learned that the real reason he left the business world was that he needed to make things with his own hands. Larry likes to concentrate on technique. He works to refine those techniques and then combines and recombines them. Larry feels that for him, bead-making is more about the making than about the beads. He says;

"Generally speaking, I think of the techniques that I know and use as intermediate and those that others know and use, and I don't, as advanced."

"Anyone who has tried it knows that making beads is an intense physical and emotional experience and it is impossible to explain this to skeptics who haven't tried."

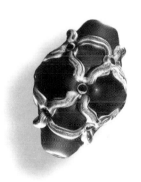

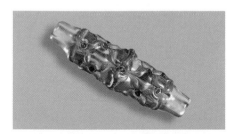

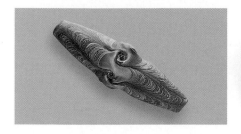

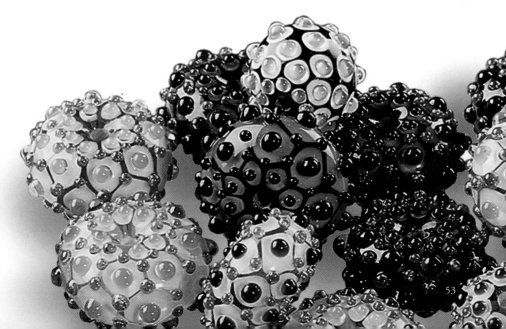

Kim Wertz

Kim's bead fetish started years ago when she was first exposed to historic beads in the eclectic shops and markets of the San Francisco Bay area. She felt drawn to the trade beads of the European and African routes, and fell in love with these well-worn glass artifacts. Before long she stumbled on the beginnings of the contemporary art glass movement and the next step in the continuum seemed clear – sooner or later, Kim would be behind the torch herself.

She and her husband Greg Galardy left their hectic careers in Silicon Valley and made the great escape to the "wilds" of the North. Letting their passions be their guide, they opened a bead store which allowed them to really indulge their mutual love of glass beads. This also led to the contacts and information needed to actually make the glass beads. Kim has yet to look back.

"After many years of 'playing with fire' for a living, the mystery and romance of my first encounters with glass beads still remain. I'm constantly inspired by the connection to past traditions as I work with the same techniques used in centuries-old beads."

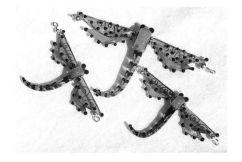

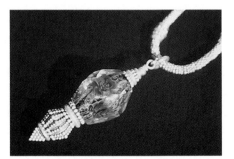

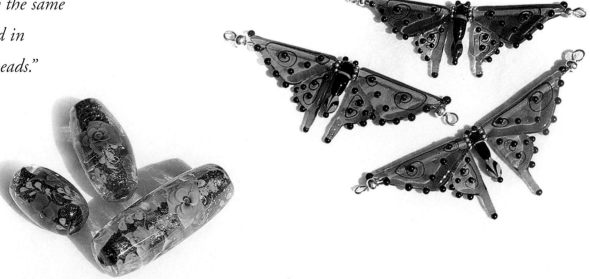

Greg Galardy

Greg has always loved glass. He was that kid who spent countless hours on a camping trip trying to get pop bottles to melt in the campfire. In 1996, he got his first torch and at last could learn how to melt glass "for real". While twirling his first colored blob of glass on the mandrel, a rush of ideas flooded Greg's brain and it has been a full time obsession ever since.

Greg likes to make his beads look organic, so it seems as if they could have been found in nature. This means muted earth tones – like rocks in the bottom of a stream, or trees and grass through the fog.

Lately Greg has been toying with coldworking (lapidary) equipment. He builds elaborate multi-layered beads and then slices sides off here and there, exposing different aspects of the complex layers lying underneath. He finds it fascinating to take these beads to his lapidary wheel and "unwrap" the layers to see if what he envisioned at the torch is there inside.

"The more I work with glass, the more I learn directly from it. Turning this knowledge around and applying it back to the glass makes this learning cycle continuous. The glass itself is the best teacher of all."

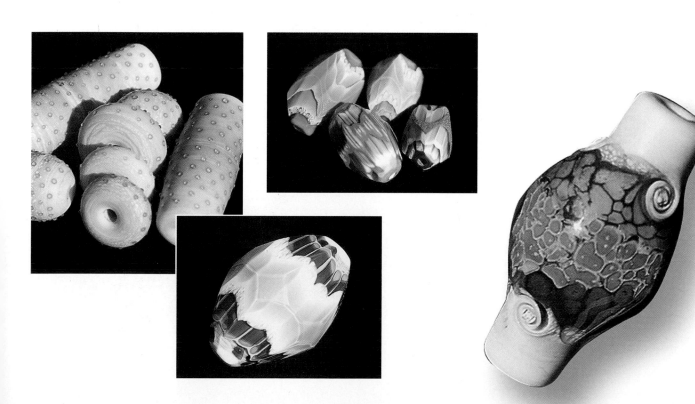

Cheryl Spence

"After a day of working at the torch, the following morning provides a welcome 'presents under the tree' thrill."

After graduating with a degree in Interior Design in 1976, Cheryl worked with several architectural firms doing space planning, rendering and interior design for commercial clients. During this time she was making jewelry with an eclectic ethnic feel and became interested in beads. For a while she was taking workshops in all aspects of jewelry making. This adventure took a decided turn when Cheryl was able to attend the 1990 International Bead Conference in Washington, D.C.

As a result of that conference, Cheryl ended up hosting two week-long workshops in glass beadmaking and fusing in 1991. These took place in her two-car garage. After the workshops, she was hooked. By the end of the year she had an in-home studio and has been creating wonderful glass beads of her own ever since. Though not intentional, her beads tend to resemble gemstones, sea and landscapes, and even galactic panoramas.

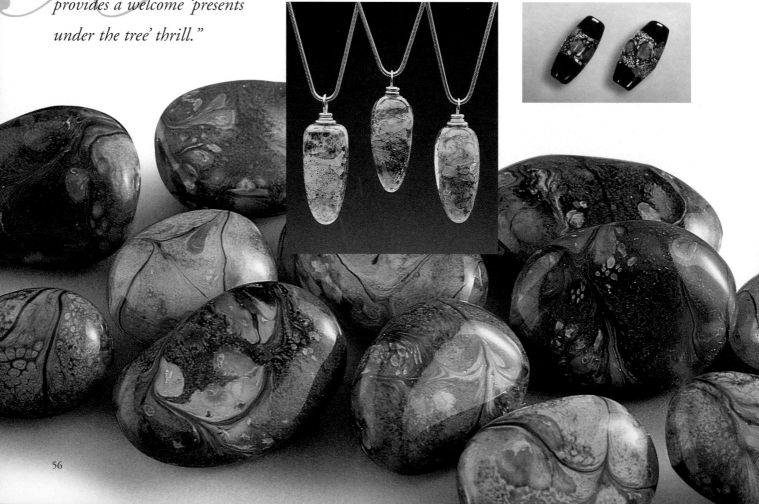

Michael Mangiafico

Michael taught himself how to make glass beads after seeing a lampwork setup in someone's basement. He has a BFA in Glass Art and had already been working hot glass at the furnace for years. In his excitement to start working at the torch, he boiled all his first beads with an oxy-acetylene torch. Now an accomplished lampworker, Michael teaches classes in both torchworking and glass blowing.

The direction that Michael's artwork is taking him now is working smaller and smaller until the pieces are microscopic. When he makes his glass insects, he starts on one side and works his way to the other, never going back. For example,

he creates an abdomen and then works his way to the thorax. When working on the thorax, the flame never touches the abdomen. Michael then adds the head and the first segment of the legs, wings and antennae. As he works the rest of the segments of the legs, he is careful not to heat the rest of the piece which has already cooled. The finished insect then goes directly into an annealer.

"The things that inspire me the most are my wife and her art, insects, the Blaschkas, cooking, glass art, micro-miniature art and money."

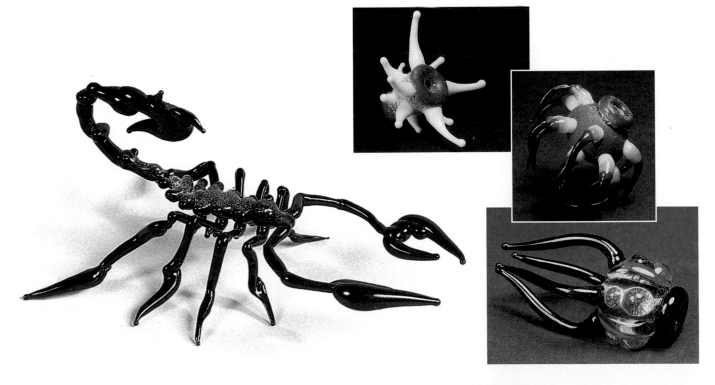

Kate Fowle Meleney

Kate's love of beads came long before she started making them. As a goldsmith's apprentice, she often combined African trade beads with her metalwork. After seeing a demonstration of glass beadmaking in 1990, she knew that she had to learn. She saw it as a way to have total control over her finished product. It took six months to get into a class, but then every spare moment was spent at the torch trying to master decorative techniques that she was interpreting from catalogs and books.

Kate worked in textiles for years, then moved on to metalsmithing and enameling. Textiles and enamels honed her color-combining skills and metalsmithing had a number of things in common with beadmaking. This gave her a good foundation, which she has been able to expand on. You can see all these disciplines coming together in her beautiful electroformed beads.

"I hope that 10 years from now I'll still be experimenting, still be surprising myself when I open the kiln and still be sharing this exciting medium with others."

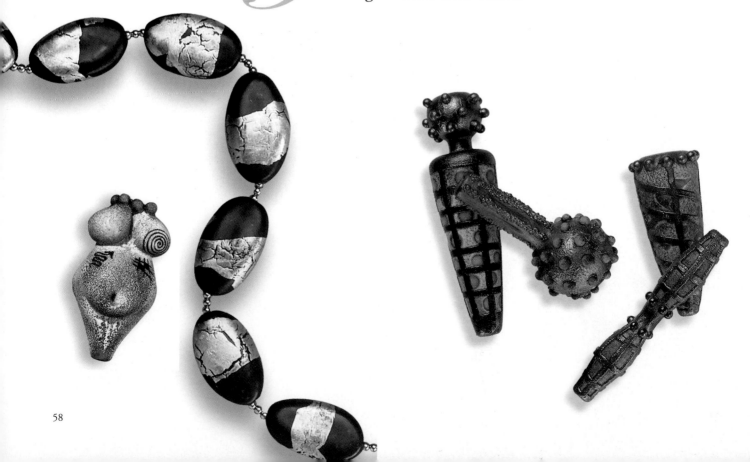

Karen Ovington

After many careers, including dental assistant, cosmetic buyer and manager of a department store, Karen has finally found her niche. Her start in glass beadmaking came about as a result of her fused glass "women" sculptures. She thought beads would be a great addition to the mix and started using them for hair. She continued to use more and more beads in her work. Finally, someone suggested she might want to make her own beads. Karen thought to herself "Who has time for that?"

As fate would have it, there was a glass beadmaking class coming up soon at a local glass supplier. She took the leap. All of her first efforts remained stubbornly stuck to their mandrels. Another year went by and another class came up. Despite her first experience, she took the leap again. That was what did it.

Next came the search for her own "look." She had always been mesmerized by Egyptian glass and the surface it acquires from being buried. After much experimentation, she was amazed to find that people not only liked what she was doing but were willing to pay money for it. Her fate as a glass beadmaker was sealed.

"My work is largely spontaneous. I never know how a bead will end up. If the bead wants to go in another direction than I imagined, I never fight it. I love texture! I love color! Working with glass allows me to continue the adventure."

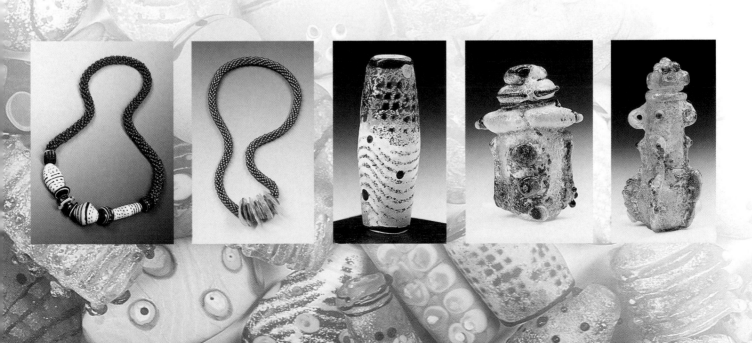

Dan Adams

Dan was born and raised in the Pacific Northwest and has a degree in Anthropology.

He met and began making beads with his wife, Cynthia Toops, in 1986. They initially worked in polymer clay, but after taking a class in 1990 they started to make flameworked beads as well. Dan was introduced by members of the Northwest Bead Society to old beads and ethnic jewelry. These pieces have had a direct influence and served as inspiration for his beads.

Lately, he has been collaborating with a Seattle metalsmith to make finished jewelry pieces with his beads. Today, besides working full time as a histotechnician in a cancer hospital, Dan teaches and is an amateur cook.

"Most of my lampworked beads are created with a piece of jewelry in mind rather than as individual beads. Because of this, and contrary to other glass bead-makers, my beads have become smaller and simpler over the years."

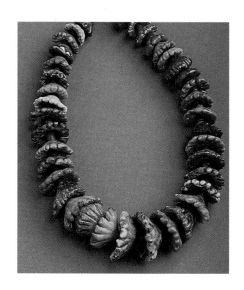

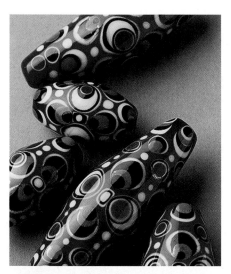

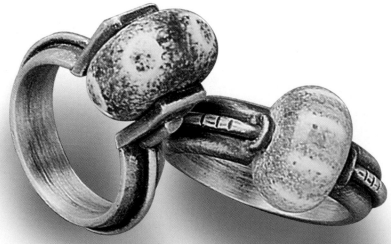

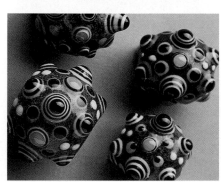

Al Janelle

Al's interest in molten glass started with a beginning beadmaking class in 1994. Like many others, he was hooked from that day forward. Within a year he had set aside his cabinet-making tools and switched over to lampworking tools. Since that time he has spent thousands of hours at his torch.

Al continues to expand his skills by experimenting extensively with new techniques. His sculptural bird and animal beads reflect his keen interest in achieving an accurate likeness. The detail and expression in the faces of his animals make them seem almost lifelike. Many people can hardly believe that they are lampworked glass. His creations have taken detailing in glass to another level. Al is also well known for his colorful latticino canes that have been used to embellish each of these artist pages.

"The skill that makes this art form unique is working with both hands within inches of an intense flame, during which you're coaxing a solid form from liquid glass that doesn't necessarily want to acquire and retain a shape."

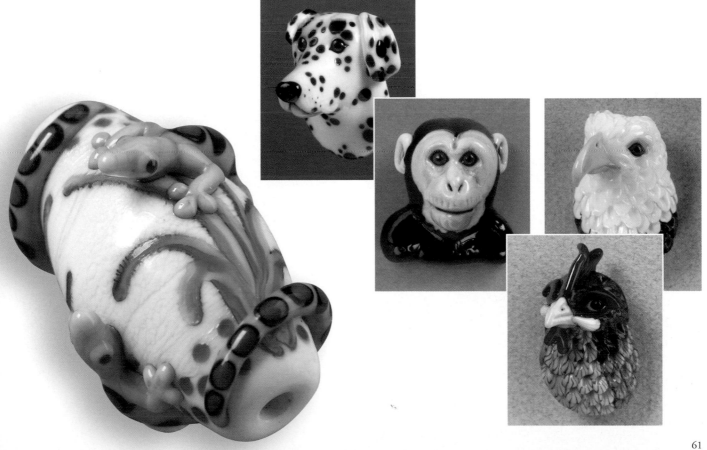

Terri Caspary Schmidt

Terri made her first bead in the summer of 1999. As a full-time nurse-midwife for almost a decade, she has had to squeeze her creative life into a hectic schedule. Her first focus was on fiber arts, but Terri had always been fascinated with hot glass. She loved watching glass blowers at work but thought the training and equipment was out of her reach. Through voracious research Terri stumbled upon the glass beadmaking move-

ment and realized that people were making wonderful miniature sculptures in glass with not much more than a torch and a kiln.

Like most people discovering glass beadmaking for the first time, Terri was thrilled by the work of the early beadmakers of the movement. She rented studio time for two years before purchasing equipment and building her own tiny studio. Today Terri is happily committed to what she calls a wonderful and mysterious craft.

"Hundred of beads later, I find myself completely absorbed in one of the most satisfying mediums of creative self-expression I have ever known."

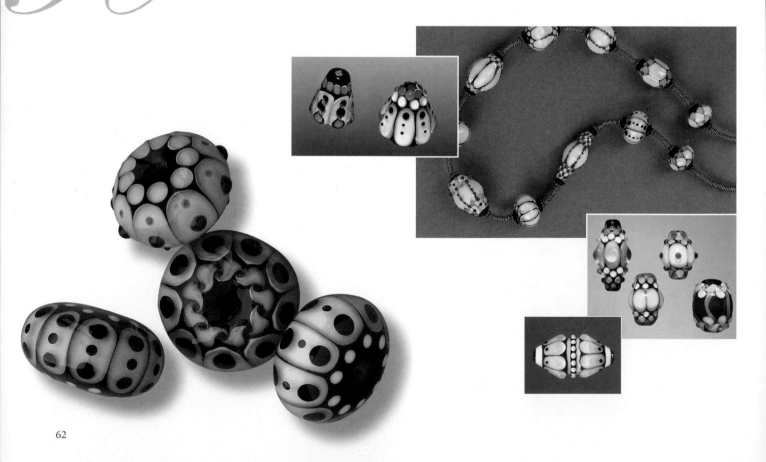

Kim Fields

For as long as she can remember, Kim wanted to be an artist. She majored in advertising and served as art director for the student newspaper. Kim started her career at a local radio station and was soon writing copy and producing commercials. This led her to New York and then to Chicago and eventually into television production. Along the way, she was honored with three Emmy awards.

All the while, Kim kept up her artistic endeavors on the side. In the search for great beads for her projects she discovered lampworking. She took a class in 1999 and after making beads for just a few months decided to change careers. She now makes glass beads and designs jewelry full time.

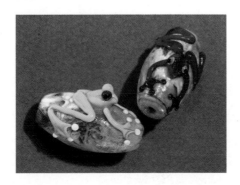

"Lampworking is like nothing else I've ever done. I must admit that I am mesmerized by the dance of glass and flame, and by how time is suspended while I am over the torch."

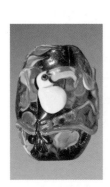
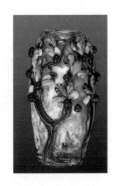

Diana East

Diana has been working as a jeweler since 1978. In 1987, while looking for a different medium, she attended an exhibition of the glass jewelry of Rene Lalique. Here she was inspired to rediscover her interest in glass. In 1994, she began making glass beads. With no available instruction, she had little success. Since there was no glass beadmaking information available in England at the time, she knew nothing about glass compatibility or annealing.

In 1997, Diana came to the United States and spent two months studying beadmaking. She absorbed much from observation and access to pertinent books. Since then she has attended many more glass classes, always learning new skills. Her beads have many layers of artfully combined techniques, making them truly unique. There is still limited exposure to beadmaking processes in England, so she continues to teach one-on-one in her studio.

"I am beginning to feel that I can make the glass do what I want it to do on a small scale."

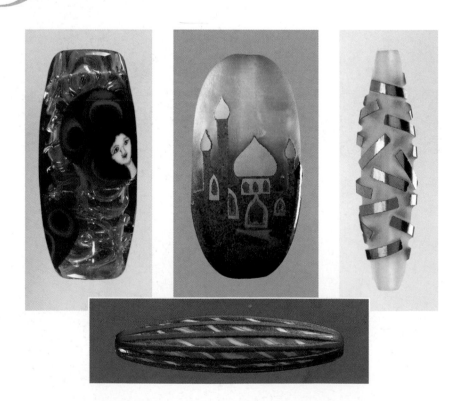

Loren Stump

Loren began his glass career making stained glass windows. He had been doing this for almost twenty years before he made his first bead in 1993. Loren proved to have a raw natural talent for working glass at the torch. He took immediately to glass bead-making. Though he has had little formal instruction himself, he has been able to produce such outstanding beads that a demand for classes grew almost immediately. Loren is a tireless instructor with lots of patience and a seemingly endless supply of knowledge and energy.

Loren is well-known for his intricate murrine designs capturing everything from pure whimsy to religion. One innovative murrine technique which Loren developed is that of manipulating a two-dimensional murrina slice into a three dimensional sculpted form to make it appear more realistic.

Over the years, Loren's beads have grown larger and larger until he finally started leaving out the hole and they became small statuary. Now even his statuaries are becoming larger. Because Loren has always been at the cutting edge of the craft, he has had to design a lot of tools and equipment that previously didn't exist. We're all grateful.

"More than half the work I do is teaching. That is what I enjoy and I teach everything I know. I don't believe in keeping secrets."

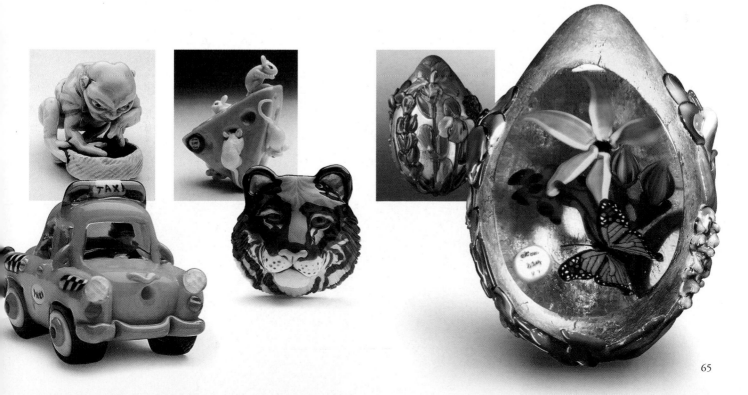

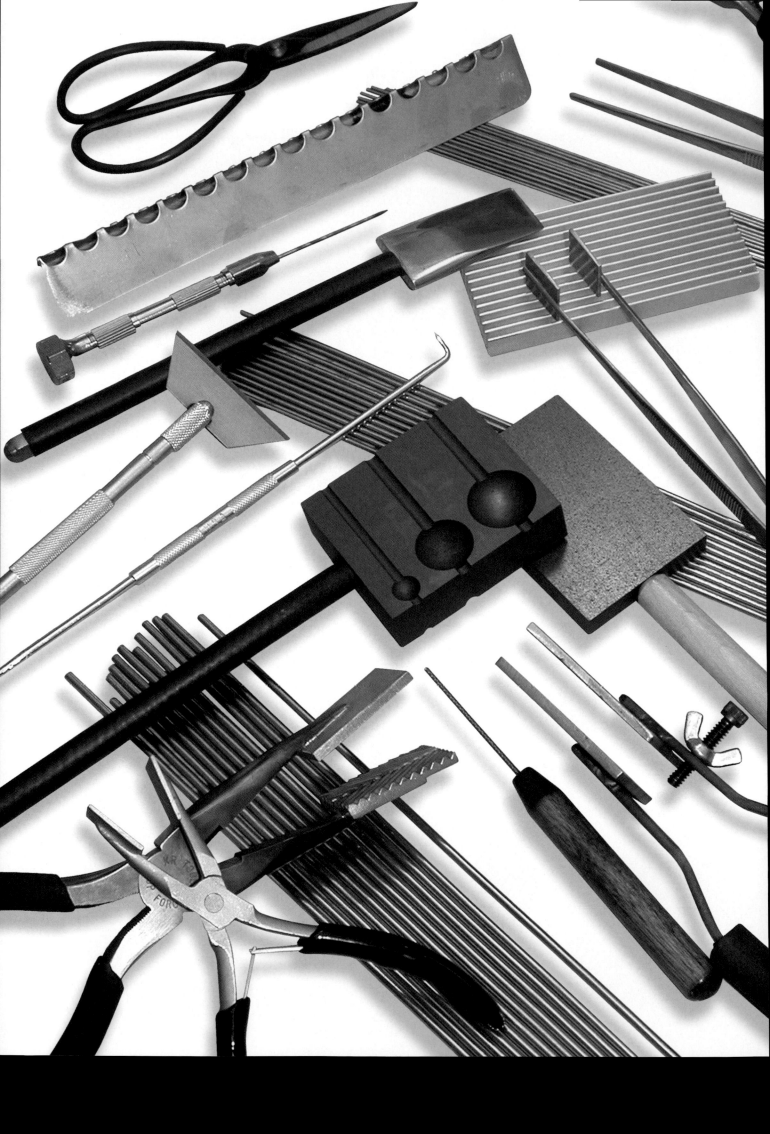

Techniques

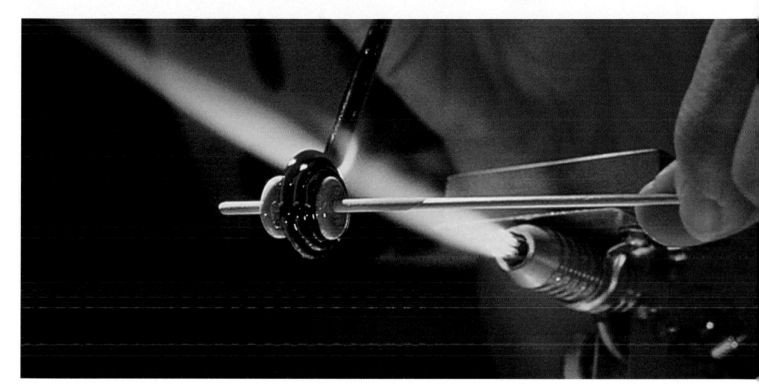

The following pages contain a wide variety of techniques from more than 50 contemporary glass beadmakers. The techniques represent countless years of collective experimentation and work. These artists have generously shared their hard-won pools of knowledge with all of us. Each technique is described and shown in photographic steps, so you can see exactly how everything is done.

A few techniques are presented as overviews because they involve processes that are beyond the scope of this book. The beads made with these overview techniques are so unique and interesting that they have been included just to give you an idea of how they were made.

The techniques range from basic to advanced. There is something for everyone. After a look through these pages, you won't be able to wait to get to your torch and start your own experimentation.

Round, Round Bead –*Larry Scott*

The title of this technique sounds redundant but when you think about it, you seldom see a truly round bead. They usually look more like fat dough-nuts. Larry learned this technique from Andrea Guarino. He views it more as an exercise in how glass moves but when I want a round bead this technique works for me every time.

1— Start with a cylinder the width that you want your finished round bead to be. Think small to start. Add a thick disk of glass to one side.

2— Put a second disk of glass on the other side. For illustrative purposes, Larry has used three different colors but you can make it all one color.

3— Hold the mandrel so that the torch flame is aimed directly down the center between the two disks. Remember that glass moves toward the heat.

4— The glass is now starting to melt.

5— The bead is getting rounder. The bead frequently looks a bit off at this point but it should still come out round.

6— Looking good!

7— A truly round bead. Notice how the white glass has moved toward the center too.

8— This bead will have straight sides. The hole may not be dimpled in but it should not be sharp either.

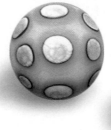
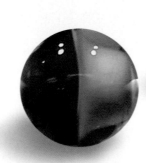
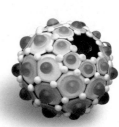

Tapered Barrel Bead –*Kim Affleck*

Kim learned to make beautifully shaped beads from Jim Smircich. She has also provided her own additions and tips in these instructions.

Kim likes to begin with a simple cylinder about an inch long. She uses approximately 8" of rod for the cylinder which ends up about ¾" thick. She marks off her glass rods in inches so she knows how much she has used.

1— Direct your torch flame to the center of the bead cylinder and heat the entire mass of glass. This causes the glass to pull to the middle of the bead.

2— Keep the mandrel level and roll it at a steady pace. The glass will center itself and develop a thick round middle with a football shape and pointed ends. Let the bead cool until it has lost its glow. This will allow you to work on the bead ends without distorting the middle.

3— Begin shaping one end of the bead by tilting the mandrel to a 45° angle. Heat the lower half of the bead while rotating the mandrel.

4— Continue to heat and rotate the bead until the glass begins to flow over the pointed end.

5— When one end is nicely dimpled, pull the bead out of the flame and continue to rotate until it is cool.

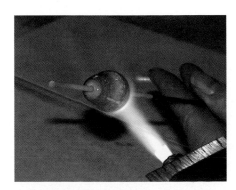

6— When the dimpled end of the bead has cooled enough so that the glass no longer glows, repeat the shaping process on the other end of the bead.

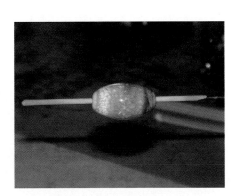

7— The finished tapered barrel bead.

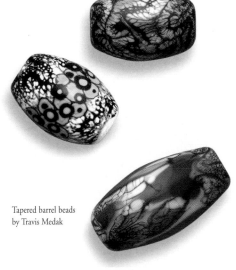

Tapered barrel beads by Travis Medak

Batwing Bead –*Patti Dougherty*

This is a fun, different and relatively easy bead to make. Snipping a bead with scissors can add shape and/or texture.

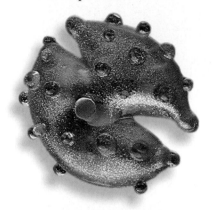

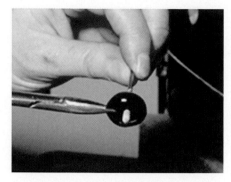

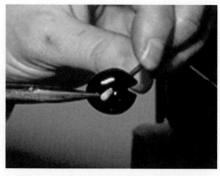

1— Make a saucer shaped bead, about 1" in diameter and $^3/_4$" thick. Heat the bead to a dull orange color on one side. Remove the bead from the flame and quickly snip into its side to a depth of about $^1/_4$". Make sure to do this outside the flame or the scissors blades might stick to the bead.

2— Repeat this snipping process on the other side of the bead. Remember not to cut too close to the mandrel. One swift movement of the scissors is best. If the scissors sticks, the glass is too hot. If you hear a clink, the glass is definitely too cool.

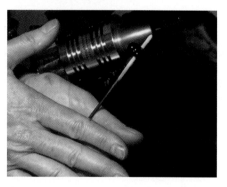

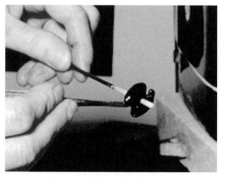

3— Now that you have two snips, reheat the bead, concentrating on the cut areas. With the cut areas glowing, hold the mandrel between your palms and gently spin the bead. Centrifugal force will cause the edges to elongate and stretch the bead into "batwing" shapes.

4— If you want to exaggerate the batwing shape, heat the tips of the wings to a glow, touch them with cold stringer and stretch them out a bit.

5— At this point, Patti likes to cover the bead with pixie dust and then add raised dots.

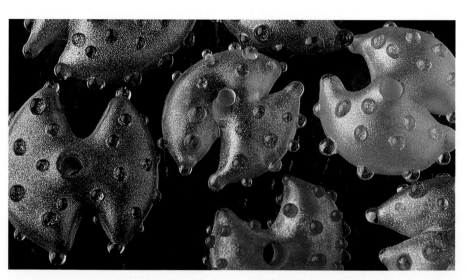

6— The finished batwing bead

Melon Bead – *Kim Affleck*

For the melon bead, start by making a tapered barrel bead as shown on page 69.

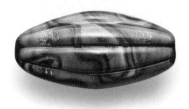

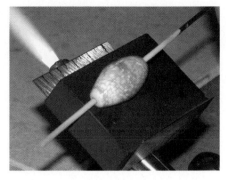

1— When you have a nicely balanced tapered barrel bead, marver the ends down into a narrower point.

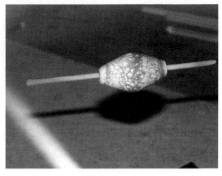

2— The finished shape after marvering will be a bicone with a large rounded middle.

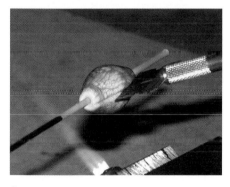

3— Allow the bead to cool. Now move the bead horizontally across the flame to heat a thin line along the length of the bead. If you can adjust your torch flame to a tight cone, it will make things a bit easier. When the line is red hot, cut a groove into the bead parallel to the mandrel using a single-edge or utility razor blade mounted in a pin vise.

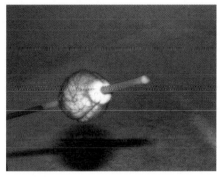

4— Use the first groove as a guide to help get the rest of the grooves evenly spaced. To do this, turn the mandrel so that you are looking at the end of the bead. Heat a spot on the end of the bead directly opposite the first groove and make a nick with the razor tool.

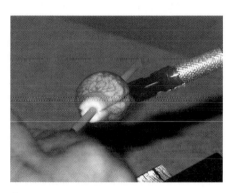

5— When you have the nick on target, heat a line along the whole length of the bead beginning where you made the nick. When the glass is hot enough, cut a second groove.

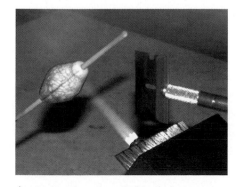

6— Looking down the end of the bead again, make nicks on the end between the two grooves on both sides. Heat and cut two more grooves between the first two. You should now have four evenly spaced grooves.

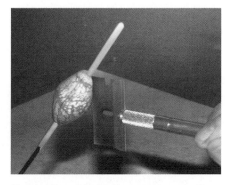

7— Continue nicking and cutting grooves until you have eight equally spaced grooves.

8— The finished melon bead.

Easy Heart Bead –*Peggy Prielozny*

1– Make a round bead. You can use any surface decoration you like. This bead has four stacked dots, two on each side, staggered between each other.

2– Loop a twistie cane around the dots.

3– Keep looping the twistie around until it meets back at the beginning.

4– With the excess twistie hanging off the bead, use your rod nippers to cut it off flush.

5– If necessary, use a tweezers to straighten the ends where they meet.

6– Melt the design into the bead.

7– The design is now melted flush with the surface of the bead.

8– Use your bead squashers to flatten the round bead. Do this slowly and carefully. If you have a pattern that needs to lay a certain way, pay particular attention as you perform this step. Don't squash the bead too flat.

9– Your bead should now look like this.

10— Heat the flat surfaces of your bead until all the chill marks are polished out.

11— Your bead should now be at the proper temperature to form the heart by pushing the sides up. A modified pair of tweezer mashers was used here, but you can use a graphite paddle to get the same effect. It is easier to get both sides pushed up evenly with the modified tool.

12— The modified masher creates the heart shape almost automatically.

13— Reheat and flatten the heart again if necessary.

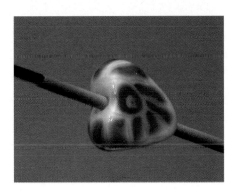

14— You can consider the bead finished at this point if you like.

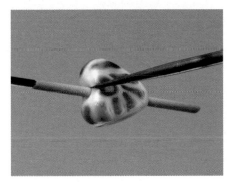

15— You can also continue on and use a raking tool to create a little crease at the top of the heart.

To modify a tweezer masher for making heart beads, place one entire masher pad into a bench vise so that the bottom edge of the pad is flush with the top of the vise and gently pull back. Bend a little at a time until you are satisfied with the angle. It helps to have a pattern. Repeat on the other side. The tool was not designed with this in mind, so it is possible that you could break it. Be careful.

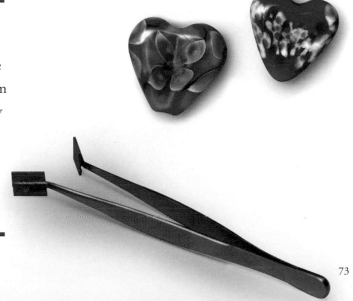

Precise Dot Placement —*Larry Scott*

To divide a bead up into regularly placed dots, start with a well formed sphere or torus (bagel shaped) bead.

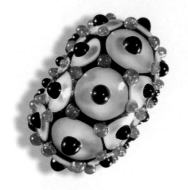

1— Apply the first dot to the equator of the bead, centered left to right.

2— Rotate the bead so that this first dot is at the top horizon. The mandrel now appears to pass through the bead exactly 90° from the first dot. Place the second dot on the equator of the bead at the spot where the mandrel appears to pass through the bead.

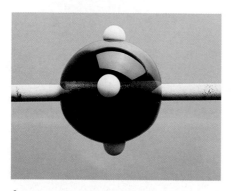

3— Move this second dot to the upper horizon and place a third dot over the mandrel line. Repeat this for the fourth dot. The bead should now be divided evenly by four dots.

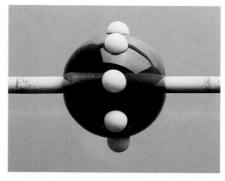

4— Place a dot between each of the original four dots to divide the bead into eighths.

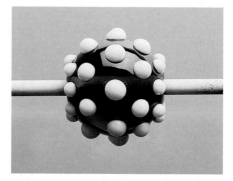

5— Once the middle dots are in place, you will be able to use them as markers to add additional dots along the sides if desired.

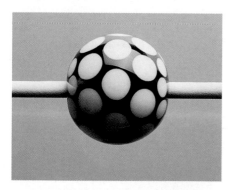

6— Slowly melt the dots all the way into the surface of the bead.

The trick to achieving crisp edges on your dots is to melt them in slowly. Think about heating the dots rather than the bead. By heating the dots and then removing the bead from the flame to cool slightly and repeating the process, the dots will spread out over the relatively cool surface of the bead and the edges of the dots will remain distinct. If the whole bead is heated too quickly, some of the base color is likely to well up over the edges of the dots and make the dot edges appear less crisp.

Dot Pattern Variations –*Larry Scott*

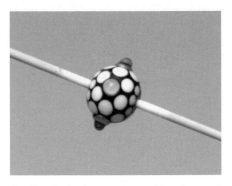

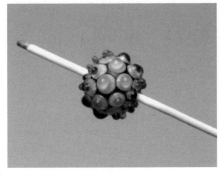

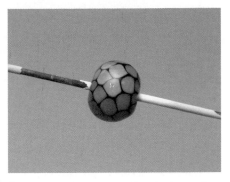

1— To make the dots spread out and form hexagonal patterns, each dot must be carefully cased with a drop of transparent glass. Heat only the tip of your transparent glass rod. With the rod perpendicular to the surface of the bead, bring the molten glass down and cover the base dot, pushing the transparent glass out to the edge of the dot. Pull back slowly and burn off the trailing glass in the flame. The glass left behind will look very much like a Hershey's Kiss.

2— Case all the base dots in this same manner. As with the base dots, the secret to achieving a clean and uniform pattern is to heat and reheat, allowing the casing to melt in slowly and spread evenly. The finished pattern depends on the placement and the size (volume) of the dots.

3— A classic hexagonal pattern can be done with five rows of eight dots staggered in the adjacent rows. (This could be called an "eight around, five across staggered dot pattern.")

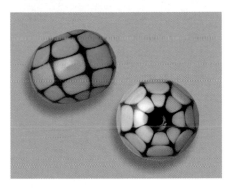

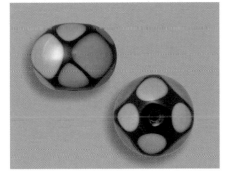

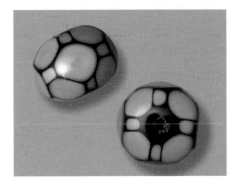

4— Squares can be produced by aligning, not staggering, the dots. The example shown here was made with an eight around, five across, aligned dot pattern.

5— Large central squares, suitable for further decoration, can be produced by placing four large dots around the equator and staggering four smaller dots on each side of the large dots.

6— This pattern of large octagons separated by small squares can be created by first placing four large dots around the equator. Add four small dots between these large dots. On each side of this central row, align four small dots next to the large central dots and four large dots next to the small central dots.

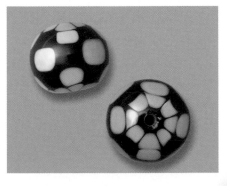

7— Larry calls this technique "blind dots". Blind dots are the same color as the bead itself. Even though they will disappear into the bead and become invisible, they will still cause the adjacent contrasting color dots to move and form patterns. Blind dots will work with any of these variations.

Hot TIP

Larry keeps a tile grid mounted on the wall in front of his torch station. The horizontal lines help him keep his mandrel level.

Bonus tip: *Here is how Larry gets such beautiful holes in his finished beads.* First he uses a diamond dremel to clean out any bead separator residue. He then dips a ¹/₁₆" mandrel in clear nail polish and runs it through the center of the bead. This takes away the matte surface and makes the holes almost disappear.

Striped Bead – *Various Artists*

These beads are quick and fun to make. They are also a great way to increase your skill at dot placement. It is important to be able to control the placement and volume of the dots on these beads in order to get a symmetrical pattern. The clear casing magnifies everything underneath, including mistakes. Get out your brightest, most playful colors and have some fun. Even if the first few don't turn out perfectly, they'll still look good enough to eat.

1— Make a very small bead, approximately ¼" high and ⅛" wide. You may want to use stringer to make this bead. With such a little bead, putting a small dot on the mandrel helps with dot placement.

2— Place the first dot on the bead aligned with the dot on the mandrel. Turn the mandrel around until you can no longer see the dot on the mandrel. Place your second dot aligned with the mandrel. These two dots should now be directly opposite each other.

3— Using the first two dots as guides, place a third and fourth dot in between the other two. Round these dots out a bit but do not melt them in.

4— Wind a thick (⅛") clear stringer over the tops of the raised dots. Go around the center of the bead twice, with the second wrap directly on top of the first. To keep the stringer from stretching as you wrap, keep a slight pressure on the stringer toward the bead.

5— This is a view of the finished casing wrap. Having the wrap thin, centered and high is what pushes the dots into stripes.

6— As you begin melting the clear wrap, you may find it necessary to straighten and center it with a tool. It is important for the clear wrap to melt in evenly, so the stripe pattern is not distorted.

7— Continue heating, melting and straightening as the clear wrap is melted in.

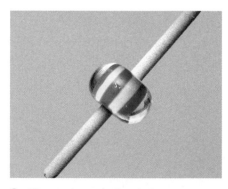

8— The wrap is completely melted in.

Triangle Dot Bead —*Various Artists*

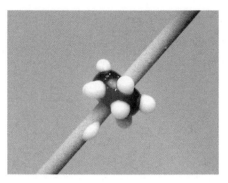

1— Make a small round bead with a pattern of staggered dots. This bead has four white dots on each shoulder. Melt the dots in a bit.

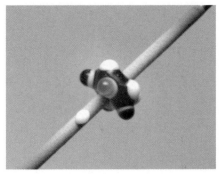

2— Add transparent colored dots on top of all the white dots on one side of the bead.

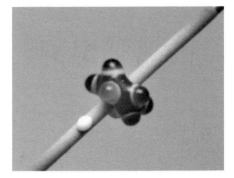

3— For contrast, add a different color of transparent dots to the white dots on the other side of the bead.

4— Melt all the dots in.

5— Using a thick (about ¹/₈") clear stringer, make a double wrap around the center of the bead, one wrap on top of the other.

6— Use a paddle or other tool to straighten the wrap if needed. This helps the wrap to melt in evenly. This is important in order to keep the pattern true.

7— Melt the wrap into the surface of the bead.

8— Your triangle dot bead should now look like this.

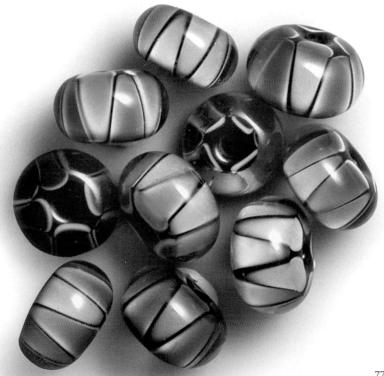

Fish Scale Bead —*Sage*

1— Add 4-6 evenly spaced white dots around one end of a cylinder bead. Melt these dots down flat. Add transparent color dots on top of the white dots and melt in flush with the surface of the bead.

2— Add a second row of white dots staggered in between the first row of dots and partially overlapping them. Melt these dots in flat.

3—Add transparent dots on top of the second row of white dots.

4— Melt the dots into the bead surface and use a marver to maintain the cylinder shape if necessary.

5— Add a third row of white dots staggered in between the dots in the second row. This third row should line up with the first row and partially overlap the second row.

6— Melt the white dots in. Add transparent dots on top of the white dots again. Melt these dots in flush. Continue adding rows in this manner until the surface is covered.

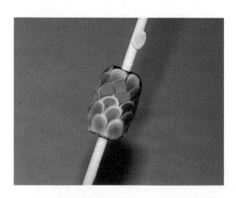

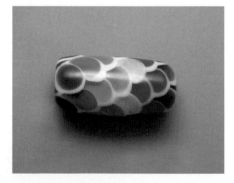

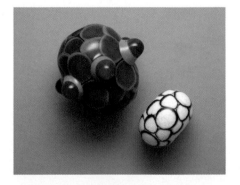

7— The finished fish scale bead.

Variation Fish scale bead with rainbow colored dots.

Variation Dots coming from both ends toward center. Central row overlaps both sides.

Frit Stringer—*Various Artists*

1— To make small amounts of frit, heat up approximately 1" at the end of a glass rod and plunge it into a bowl of water. This will fracture the glass and make it easy to break up. Pour the fractured glass onto a coffee filter and allow it to dry.

2— Make up a mix of frit colors. For this example a large number of assorted greens were used to create a vine stringer. Throw in a little black or red to spark it up a bit.

3— Heat up the end of a glass rod and push it into the frit assortment.

4— Make sure you have a good layer of frit on the glass rod. If the layer is too thin, reheat the rod and add more frit right on top.

5— Use a flattening tool to help smooth out the surface as you melt the frit into the glass rod.

6— A view of the glass rod with the melted-in frit. Heat the whole thing to a molten state and pull it into a medium sized stringer.

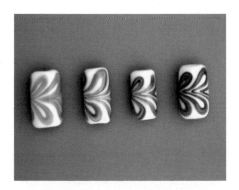

7— These beads show examples of the frit stringer used as a vine background. Notice how using a different color rod for picking up the frit changes the color balance of the stringer.

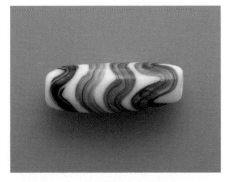

Variation Try using browns for a branch mix. Make a mix of blues, purples and pinks, etc., for a floral mix.

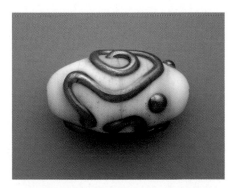

Variation Use reduction frit to make a stringer and then subject it to a reducing (gas-rich) flame after applying it to the bead. This gives the stringer a metallic surface.

Zigzag Bead —*Scott Bouwens*

1— Make a small round bead in a transparent color. Using the same color as the bead, add four evenly spaced dots on one side of the bead toward the hole. Add four more dots on the other side of the bead staggered between the original four dots.

2— Wrap a thick white stringer around the center of the bead right down the middle of the dots. If the stringer stands higher than the dots at this point, go back and add a bit more glass to the tops of the dots.

3— Melt everything down until the bead is smooth and round again. The melting dots will push the stringer into a wavy line.

4— To make the line wavier, add more transparent dots where the original dots were before they melted in.

5— Melt the bead down again.

6— The finished bead.

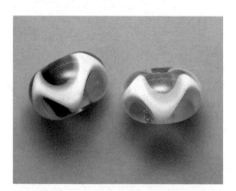

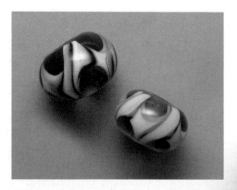

Variation using millefiori instead of the dots from Step 4.

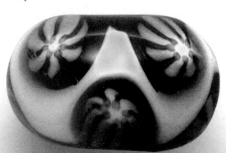

Variation using a pale transparent core and different color transparent dots on each side.

Variation using a twistie in place of the stringer.

Rainbow Bead *—Corina Tettinger*

1— Make a very small bead. For this example, a pale transparent was used. Add 4-6 evenly spaced white dots around the equator and melt in.

2— Use two different transparent colors. Starting with the darker of the two, place transparent dots on one side of the white dots, toward the hole.

3— Melt the dots into the surface of the bead. They should look off-center.

4— Add dots of your lighter transparent color on the opposite side of the white dots. These new dots should partially overlap the first transparent dots.

5— Melt the dots in. Your bead should now look like this. You can stop at this point if you like.

6— To case this bead, wrap a thick, clear stringer (about ⅛") twice around the center of the bead. The second wrap should be on the top of the first.

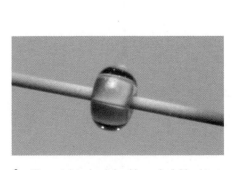

7— Slowly melt the wrap in, straightening if necessary, so that it melts down evenly.

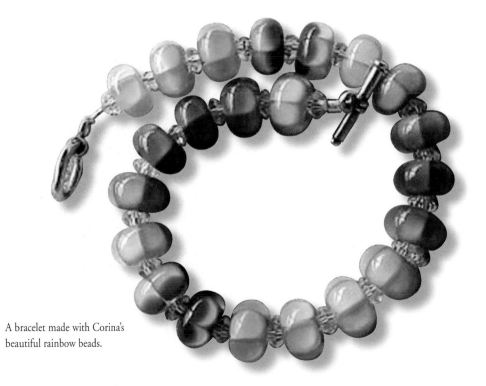

A bracelet made with Corina's beautiful rainbow beads.

8— Your rainbow bead should now look like this.

Petal Plunge Bead _–Molly Heynis_

1— Make a medium-sized round bead in a dark color. In a light opaque color, add a staggered dot pattern that is four-around the equator and three-across. Keep these dots small as they tend to spread. Completely melt the dots into the surface of the bead.

2— Cover each opaque base dot with a pale to medium transparent color and melt in completely.

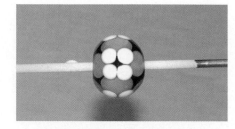

3— Add a double row of light opaque dots just to the left and right of center at the intersections of the original dot pattern. Again, keep these dots small. Melt them in completely.

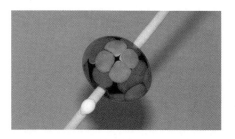

4— Cover these new opaque dots with a transparent color. This can be the same color as before, a different shade, or even a different color.

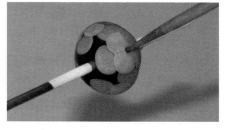

5— Spot heat the center of a cluster of four dots from the last set. Use a rake or pick to push an indentation into the center. This will pull the dots surrounding the plunge into the center, creating a petal-like look.

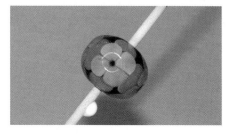

6— The indentations at the center of each set of petals should be deep enough to trap air, yet small enough to be easily covered.

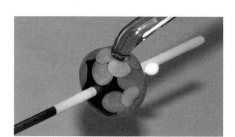

7— Using clear or a very pale transparent color, add a dot directly on top of the indentation. The indentation creates an air pocket, forming a bubble. Make sure the molten end of your rod is blunt when you add the dot. It needs to cover, not fill, the indentation. If you fill the indentation, there will be no trapped air to form the bubble.

8— As you melt these last dots in, a bubble will form in the center of the flowers.

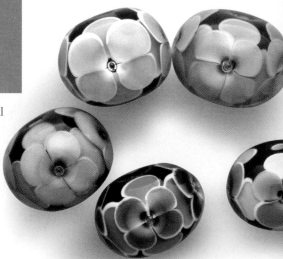

Floral Bead with CZs *–Kim Miles*

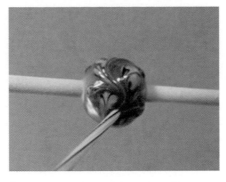

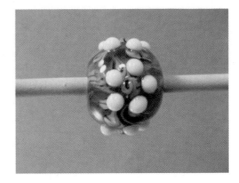

1— Decorate a round bead with stripes and dots from a striped or twisted striped stringer. If using greens, Kim likes to encase this stringer in clear or pale transparent glass because greens tend to spread as they melt. Encasing prevents this.

2— Heat the background decoration and drag through the center with a cold stringer or pick to make it look more like vines.

3— Add a ring of five dots for each flower and melt them into the bead surface.

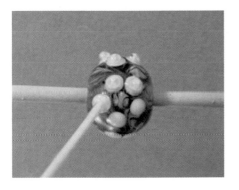

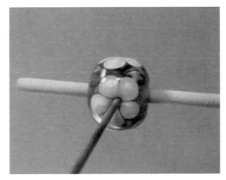

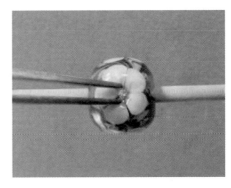

4— Cover each of the flower dots with a transparent color and melt in.

5— Heat the middle of the flower and poke the center with a tungsten pick to create a small indentation.

6— Reheat the poked center of the flower and use a tweezers to pick up and place a CZ (cubic zirconia) in the depression. The hole needs to be hot enough for the CZ to stick. Kim uses 2 mm CZs.

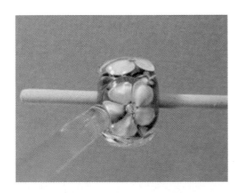

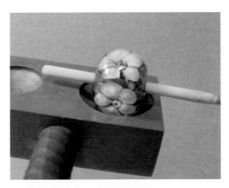

7— Heat and use a tweezers to adjust the CZ to a level position if necessary. Cover the CZ with clear glass. Make sure this clear cover is fairly thick. If it is too thin, it can crack.

8— Heat and reshape the bead.

Stratified Star Bead –*Sage*

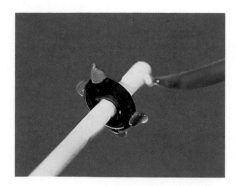

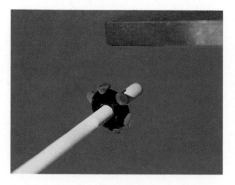

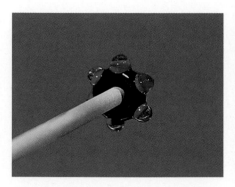

1– Wind a small transparent disk onto your mandrel and add six evenly spaced opaque dots around the equator of the bead.

2– Heat the dots and gently press down on them with your graphite paddle, flattening the tops of the dots.

3– Add a transparent color dot on top of each of the flattened dots.

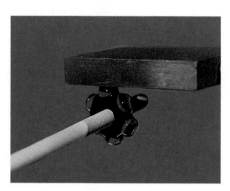

4– Heat as before and flatten the dots with your paddle.

5– Add another opaque color between the flattened dots. The new opaque dots should slightly overlap the previous dots. Reheat and paddle the new dots to flatten them.

6– Add a coordinating color of transparent glass to form a dot on top of the new flattened opaque dot. Again, paddle gently to flatten the dots.

7– Continue adding layers in this fashion. This photo shows the next layer of added dots. You will need to increase the size of the dots as the diameter of the bead grows.

8– When you have reached the desired size, you can finish with some raised dots.

Variations:

1. Change colors on each row.
2. Put millefiori on the flattened dots of the last row and add a drop of clear glass over them.
3. Add more than two colors for each dot stack.
4. Make a pinwheel pattern by alternating the color of adjacent dots on each row as shown in the diagram.

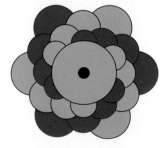

Twisted Bubble Dot Bead —*Lani Ching*

1— Prepare for this technique by making a stringer approximately ¹/₁₆" in diameter with a flat end. Make a bead with a 6 around, 5 across staggered dot pattern. Melt the dots in so that they are flush with the bead surface. Let the bead cool so that there is no glow at all.

2— Spot heat one of the dots in the central row. Working quickly outside the flame, plunge a tungsten pick into the middle of the dot. This will leave an indentation.

3— After the entire middle row of dots has been poked, cap each one with a dot of clear glass.

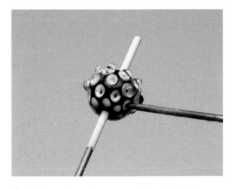

4— Poke and cap the rows on either side of the center. This photo shows a side row being finished.

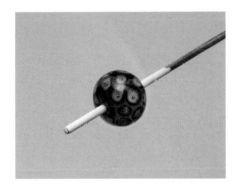

5— After all the poked rows are capped with clear glass, heat the entire bead until the clear glass is melted down flat. Bubbles should form in each of the poked dots.

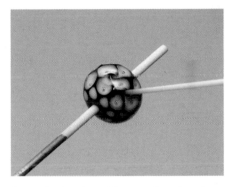

6— Go back to the middle row and spot heat the space between two of the dots. Working quickly outside the flame, push the flat end of the stringer into the heated space and twist. Remember whether you did a ¹/₄, ¹/₃ or ¹/₂ twist so that you can repeat it in each additional twist.

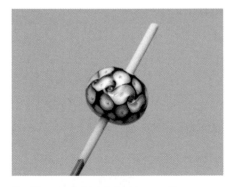

7— You may find it helpful to count off as you spot heat the spaces so that you will get a consistent heat pool for each twist. Continue around the middle row until all the dots have been twisted. You can stop at this point, or twist the spaces in the side rows.

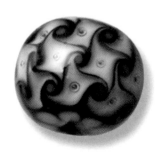

8— This photo shows twisting of a side row. The color of the stringer you use will have an impact on the finished design by leaving a dot of color that either contrasts or blends in.

Tiny Trails –*Various Artists*

1— Make a long tapered cylindrical bead.

2— Heat a contrasting colored rod until you have a pea size portion of it glowing hot. Opaque pastel colors are easier to use when learning this technique as they tend to be less stiff than transparent colors.

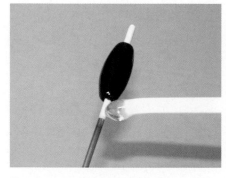

3— Touch the rod's glowing end to the mandrel near the bead's edge. By starting on the mandrel, you will avoid having a thick spot at the start of your trail on the bead.

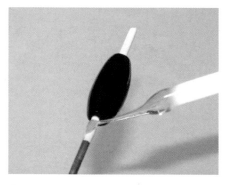

4— As soon as the glass is firmly attached to the mandrel, immediately pull back on the glass rod.

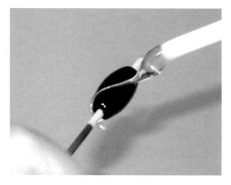

5— Working quickly, begin winding the thread around your bead.

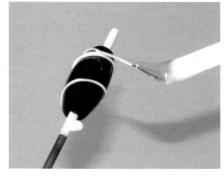

6— If you trail the glass on quickly enough, you can wind backwards over the first trail.

7— Reheat the entire bead. Make sure the trails are well adhered to the surface of the bead by marvering gently. Heat again to remove flatness and chill marks from the trail.

8— The finished bead with criss-crossed tiny trails.

Bead with random tiny trailing.

Spider Raked Bead –*Tom Holland*

1— Make a tapered barrel bead and wrap a stringer around it in a spiral fashion. Be sure to use colors with good contrast.

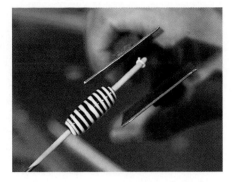

2— Melt the stringer in and then flatten the bead. Remember not to squash it too flat. Tom calls this tabulating. This step is meant to establish two sets of exactly opposite sides; the front and back of the bead will be wide and flat; the two edges will be long and narrow.

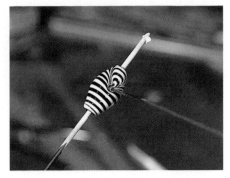

3— On the front side of the bead, rake in toward the center from all four corners. This picture shows the second of the four rakes being completed.

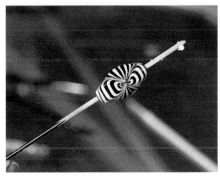

4— The four corners have been pulled into the center. Repeat the same four rakes on the back side of the bead.

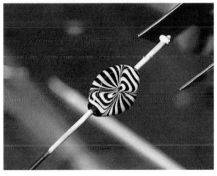

5— Give the bead a good overall heating and tabulate again.

6— Rake from the middle of the thin bead edge out toward the mandrel. Do this on both the top and bottom of the bead edge.

7— Rake the second bead edge. Heat, reshape and tabulate the bead until all the raking distortions have been smoothed out.

Bracelet showing spider raked beads.

When laying down stringer, Tom advises working at the tip of the flame. This helps to keep the body of the bead from overheating.

Pulled Floral Pendant–*Zoelle Fishman*

1– Pull two stringers in contrasting colors. Zoelle likes to pull short stringers right off the end of the glass rods. She feels that leaving the stringer attached to the larger rod gives her more stability while applying them.

2– Cut and bend a piece of 17 gauge nichrome wire which will be used as a loop to hang the pendant. 16 gauge copper wire works well too.

3– Make a grape-sized ball of hot glass and push it down on your marvering pad. Use a graphite paddle to push down the edges of the ball to form a flattened circle on the end of the rod.

4– Use a contrasting color to add a dot in the center of the flattened circle.

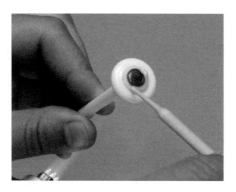

5– Outline the dot with one of your stringers

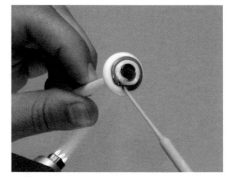

6– Outline the dot again with the second stringer. It should look like a target.

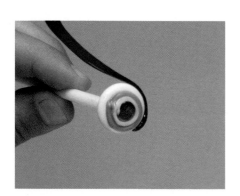

7– Wrap another color around the edge of the flattened circle to outline it.

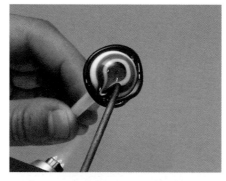

8– Using a raking tool, start in the center and pull out toward the edge.

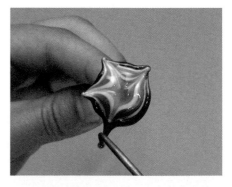

9– Continue pulling from the center out until you have completed five rakes. Notice that Zoelle likes to rake beyond the edge of the circle and then burn off the excess.

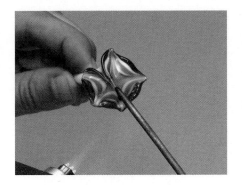

10— Rake from the edge into the center in between the five original rakes.

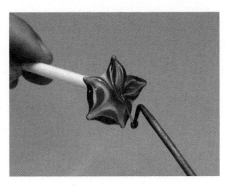

11— Continue raking until you have completed all five.

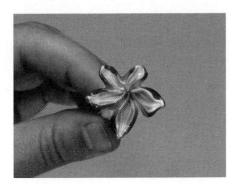

12— Completed rakes.

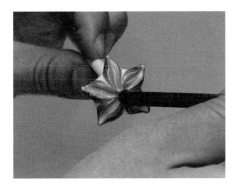

13— Attach a rod to the center of the completed floral. Use a rod the same color as the center dot.

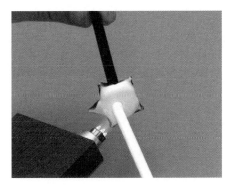

14— Remove the rod that you started with by melting it off the back side of the floral.

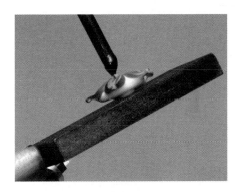

15— Heat and flatten the back of your pendant.

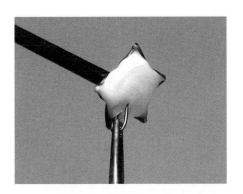

16— Choose the petal that you want as the top of the pendant. Spot-heat the back of that petal. Using a pliers, push the wire loop firmly into the heated area.

17— While still holding the loop with a pliers, melt or snap off the rod attached to the center of the front. If necessary, fire polish the break-off point.

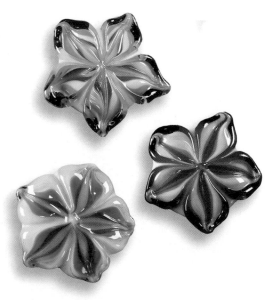

The finished pulled floral pendants. These also make great buttons; just put the wire loop in the middle instead of at the edge.

Landscape Bead –*Deb Bridge*

Landscape beads can be made by novice beadmakers and can serve as tremendous confidence-boosters. Beginners are able to try out a lot of beadmaking techniques such as twisties, enamels, frits

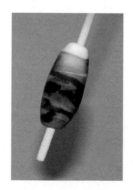

and foils without worrying about perfection. Landscape beads are realistic but also abstract enough to allow viewers their own interpretation. An added bonus is the element of surprise. With many basic techniques (such as dots), you have a good idea of what the finished bead will look like. With landscapes, there is always a bit of mystery until you see the finished bead. Try using frit, twisties, enamels and millefiori in your landscapes. Anything goes.

1— Start with a basic white or pale pastel cylinder bead with a bit of land color at the very bottom.

2— Layer on the sky by adding some transparent colors over the top half of the bead. This will allow the land to rise up to the bottom of the sky like a horizon.

3— Melt the transparent colors into the bead surface.

4— Add more land colors by starting at the bottom of the bead and layering them up to the sky area.

5— Use several shades of green in a random fashion to create a landscape. Use darker colors at the bottom of the bead to anchor it.

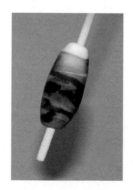

6— Melt the land colors in.

7— Add a small dot for the sun.

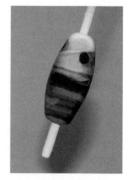

8— The finished landscape bead.

Element Bead —*Kim Fields*

Kim's exotic element beads conjure up images of nature's backdrop. Although these beads look wonderful on their own, she frequently decorates them with flora and fauna.

Select a palette of complementary colors in several opaque and transparent shades. Think of a nature theme such as forests or water when making your selections.

1— Make a small bead and marver it into a cylinder. The cylinder should be about ¹/₂" long by ³/₈" thick. Wind two disks of different transparent colors on either edge of the cylinder. The disks should be close to the same size.

2— Heat between the two disks and let them melt into the cylinder, forming a round bead. Add a stripe of white over the line where the colors meet. Kim uses Effetre anice white because she likes the way it curdles and reacts with other colors.

3— Add two different opaque colors over the transparent colors on either side of the white stripe.

4— Add more transparent colors on top of the opaque disks from the previous step.

5— Add some dark ivory glass over the top of the transparent colors on both sides.

6— Heat the bead until it is really glowing and then let the glass move and stretch. Angle the mandrel in different directions to move the glass left, right, up and down. This allows the colors to interact and form patterns. The pattern shift will depend on the angle of the mandrel, the amount of heat and how fast you are turning the mandrel.

7— Continue to "stretch and catch" until you are happy with the overall pattern. Remember you can unwind as well as wind the glass.

8— Heat and move the ends of the bead to create a tapered barrel shape as seen on page 69. This shape further stretches the glass, enhancing the pattern. It also corrects any rough ends created during the earlier steps.

Hot TIP Layering the colors in this way allows you to use many more colors than you could by just surface painting. While the result is still serendipitous, this method creates some strong crisp color bands. Using Effetre anice white and dark ivory rods create mysterious effects within the finished bead. All the super-heating involved in moving the pattern around will cause some colors to react with each other.

Webwork Bead –*Kim Fields*

1— Lay out a palette of coordinating colored rods. Pull some ivory and intense black stringers before you start. The intense black stringers need to be pulled very thin. Make a small round bead and then build up a tall disk on top of it by adding different colors in each layer as you go. Use as many layers as you feel comfortable handling. Kim likes to use predominantly dark colors so that the surface decoration will show up later.

2— Melt the disk down into a solid mass. Get this mass very hot and then allow the glass to sag and move in different directions to create a color pattern.

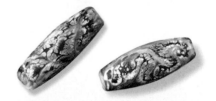

3— When the bead's pattern is as developed as you'd like, heat the ends one at a time and create a tapered barrel shape as seen on page 69.

4— Use the ivory stringer to draw a random squiggle and dot pattern on the bead.

5— Use the intense black stringer to draw on top of the ivory stringer. It is not necessary to follow the ivory lines exactly.

6— Heat the surface decoration and let it melt into the bead. Note that Kim is working fairly close to the torch in order to boil the stringer a bit. This creates the webwork design.

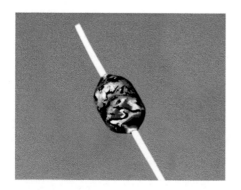

7— The webwork pattern is starting to form on the surface of the bead. Reheat the ends and shape the bead back into a tapered barrel.

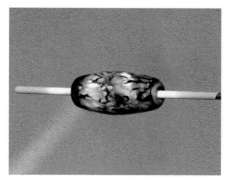

8— The finished webwork bead.

Hot TIP For a more delicate surface pattern, make a striped stringer with ivory as the core and intense black as the stripes. The intense black will then be really small when you pull it out but you will be able to work with a full sized stringer while applying the design.

Intense Black Effect –*Kim Affleck*

This beautiful bead uses the unique properties of intense black stringer as its secret ingredient. Intense black stringer is much denser than the stringer that you pull yourself from a regular black glass rod. Because intense black stringer has much more colorant in its formulation, it tends to separate when subjected to high heat. This property is exploited in this technique.

The finished bead for this technique is very similar to Kim Field's Webwork beads, but the approaches that the two Kims use are so radically different that both are featured here.

1— Wind an ivory or dark ivory cylinder onto your mandrel. Keeping this cylinder fairly soupy, start to stir in some color. Kim is using violet opaque in this example. She also likes to use coral. For this technique, you don't have to be neat. Have some fun.

2— When all the color has been stirred in, it will look something like this.

3— Add lines of intense black stringer that has been pulled very thin. The more lines you add, the more webbing you will see in the finished bead. Use it sparingly for the first few beads until you get a feel for what it does.

4— Kim frequently adds little patches of turquoise over the intense black stringer. She likes the interaction between the two colors.

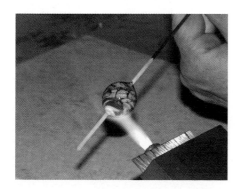

5— Let the whole mass pull into a football shape by heating at the center. Let it cool and then start heating one end.

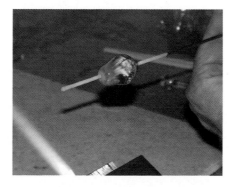

6— Using the same end shaping technique that was used in the tapered barrel bead instructions on page 69, let the glass flow over the pointed end.

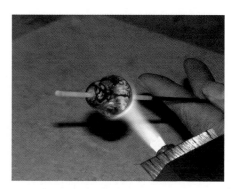

7— Heat and shape the other end of the bead.

Lapidary Bead–*Travis Medak*

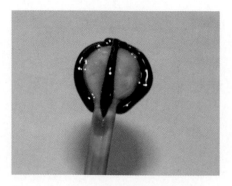

1— This bead requires a uniquely cased stringer. To make the stringer, heat an opaque petroleum green rod until its end forms a ball the size of a small grape. Add four stripes of intense black stringer, parallel to the rod.

2— Completely encase the ball in another opaque color, such as sage green. Pull this into a medium-thick stringer.

3— Make a cylindrical bead with light opaque greens or opaque turquoises. Apply the cased stringer in squiggly lines all over the cylinder from end to end. Make sure that the stringer is well adhered but not completely melted in.

4— Pluck holes in the surface of the stringer, exposing the stringer's inner colors.

5— To make the holes, spot heat a place on the raised stringer; touch the hot spot with another stringer and pull up. You may find it easier to pluck the surface with a sharp pair of tweezers.

6— As you pull away, a small hole will be created in the raised stringer. You will be able to see the inner colors. Repeat this step about every ¼" on the raised stringer.

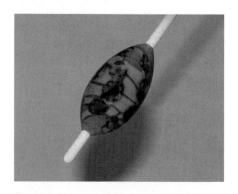

7— Melt the stringer all the way into the surface of the bead. This will allow the colors inside the stringer to start bleeding out to the bead surface through the plucked holes.

8— To enhance the pattern, use gravity to move and stretch the hot glass in different directions before the final shaping. Travis stretches his bead from end to end to create this stone-like pattern.

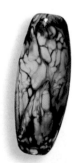

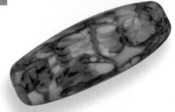

Stone Bead—*Holly Kempson*

1— To prepare, wrap the last inch of an ivory colored rod with silver foil. Melt this section of the rod into a ball and pull it into a stringer.

2— Make a bead and sprinkle a contrasting color of enamel powder on it.

3— Use your silvered stringer to add lines for veins on the bead. Put more veins on, using stringer in a similar color to the bead.

4— Melt the veins in so that they are flush with the surface of the bead.

5— Use a tool to push along the veins and create creases in the bead.

6— The finished bead.

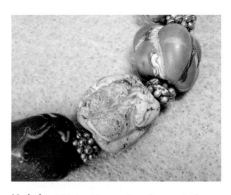

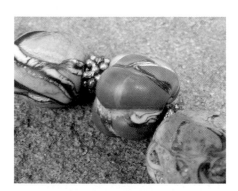

Variation This bead was done with no enamels.

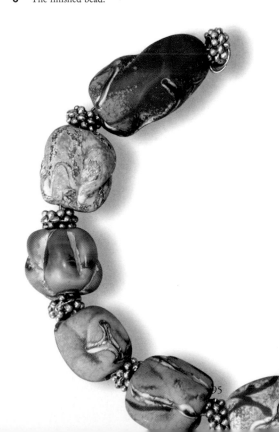

Variation This bead has patches of copper leaf applied to a dusting of white enamel and melted in, creating a beautiful mottled turquoise.

Patterned Enamels —*Cindy Jenkins*

Technique 1

1— Creating different enamel patterns on your beads is easy. In this example, enamel powder has been sifted over a marver and a piece of metal screen was laid on top. Roll the hot bead over the screen.

2— The screen creates a pattern of small squares on the bead.

Technique 2

1— Sift enamel powder over a coarse file and then run your finger over it to spread smoothly. Roll the hot bead over the file.

2— The file creates a mesh pattern on the bead.

Technique 3

1— Fill a grooved marver with enamel powder. Use a small piece of cardboard to sweep over the fins and remove any excess enamels. Roll the hot bead over the fins.

2— Depending on the direction of the roll, the grooved marver will create a straight or a spiral striped pattern.

Technique 4

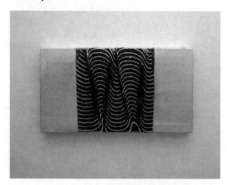

1— Sift a thin smooth layer of enamel powder onto a marver. Use a wide tooth comb to sweep through the powder and create swirls, waves, fan shapes, etc.

2— Roll the hot bead over the combed pattern.

3— The bead will have a free form wave pattern. Vary the design by using multiple colors or mixed colors. You can also combine techniques in a single bead.

Stenciled Powder Bead —*Cindy Jenkins*

1— For this technique a brass embossing stencil from an art supply or paper store is being used but any stencil with a fairly small but open design will work. This technique can be done with frit powder, reduction powder, or enamels. Lay the stencil on a marvering surface.

2— Cut a hole slightly smaller than the stencil in a sheet of paper. Place the paper over the stencil with the hole aligned over the stencil. This will catch any excess enamel.

3— Sift on just enough powder to fill the open spaces. The thinnest layer possible is best.

4— Lift the paper mask away and return the excess powder to the package.

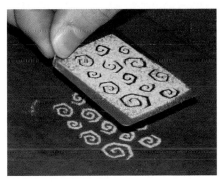

5— Lift up the stencil. (The corner of the stencil has been bent up to create a handle.)

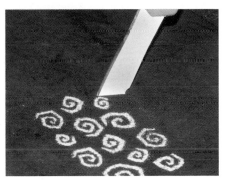

6— Tidy up any stray bits of powder so that the design won't have fuzzy edges.

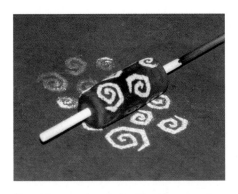

7— Make a straight cylindrical bead long enough to pick up the stenciled pattern. Heat the bead up to a glow and roll it over the powder pattern.

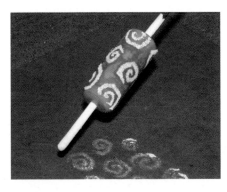

8— The bead has picked up the pattern.

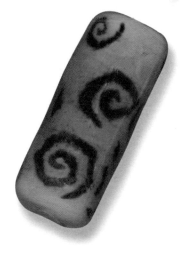

The design on this bead was made metallic looking by using reduction powders and a gas-rich flame.

Engraved Enamel Bead —*Dan Adams*

Engraved enamel beads give the illusion of age. There is no limit to the number of wonderful design variations you can dream up for this technique.

1— Choose an enamel color and then make a plain bead in a color that contrasts well with whatever enamel color you have chosen.

2— Using different types of metal tools (or other heat resistant materials) create indentations in the bead surface. Try to make all the indentations the same depth. Uneven depths will cause the enamel powders to adhere unevenly.

3— Here, metal tubing is being used to impress a circle design into the bead. Different sizes of metal tubing can make a concentric circle design. Phillips head and regular screwdrivers also make good design tools.

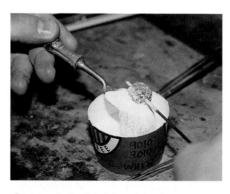

4— Heat the bead slightly and then let it rest until the surface is quite cool. Place some enamel powder on a spoon. Roll the bead in the enamel. The indentations will retain the heat longer, so the enamel will collect in these more than on the raised surface.

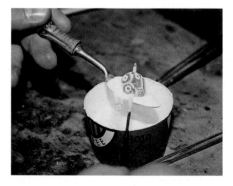

5— Continue rolling the bead in the enamel until you have a thorough coating in all the indentations. Sometimes several applications of enamel are needed. Heat the bead between applications.

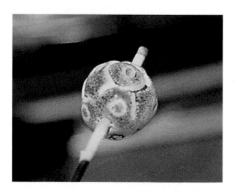

6— Slowly heat the bead until all the indentations are melted flush with the surface. The thin areas of enamel that adhered to the raised areas of the bead will start to burn off a bit and help concentrate the color in the formerly indented areas of the bead. If the bead is now uniformly covered with enamel, it was too hot when you rolled it in the enamel. If the enamel did not collect in the indentations, the bead was too cool.

Note that white enamel burns away clear while some other colors may leave a visible secondary color. For example, black becomes a variegated blue.

Variation Another way to achieve this look is to add raised stringer to the surface of your bead to form the indentations. These indentations tend to be larger and therefore stronger visually. You can also combine both techniques in the same bead.

Painted Bead —*Kate Fowle Meleney*

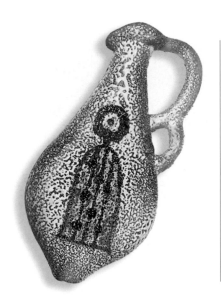

Painting on a bead surface with ceramic overglazes allows you to apply a detailed image to your bead. Kate frequently uses this technique on her petroglyph beads, which were inspired by the work of glass blower William Morris. She prefers the bead to have a rough surface, which she creates by sifting on enamels and then just barely heating the enamels in the flame. This creates a rough pitted surface on the bead, similar to orange peel. After the bead has cooled, she mattes it with an acid etching solution. She then paints this rough, parched surface with ceramic overglazes and fires it in a kiln.

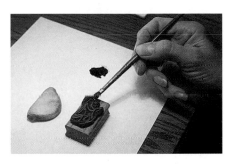

1— Use a rubber stamp to apply a rough outline for your design. (Kate uses custom-made stamps of her own drawings.) Apply the overglaze to the rubber stamp. Be careful not to use too much overglaze or it may not stamp cleanly.

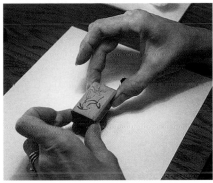
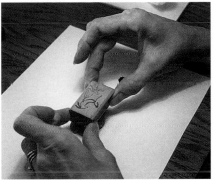

2— Carefully apply pressure on the stamp to leave the image on the bead.

3— Enhance outlines and details by painting more overglaze on with a brush.

4— Ceramic overglazes are available in a range of colors. For petroglyphs, earthtones work best. Add black outlines to your stamped image and let it dry. Turn the bead over, being careful not to handle the painted side. It is fine to put the painted side down on newspaper as long as you don't slide it around. Paint the second side and let it dry.

5— Fire the painted bead in a kiln by threading the bead onto a steel mandrel and suspending it over a Pyrex bowl. Put it in a cold kiln and take it up to 1150°F over about 30 minutes. Once that temperature is reached, turn the kiln down and vent it so it hits about 1000°F (to prevent the bead from slumping). From there use your usual soak and annealing cycle. Voila! You have a painted bead.

Hot Tip There are a number of low-fire ceramic overglazes available (such as the kind that would be used for china painting). They are available as oil or water-based pigments. Kate prefers working with oil-based pigments because they flow on better. She finds that the water-based pigments seem to dry too quickly and are also a bit granular.

Boiled Enamel Bead —*Sher Berman*

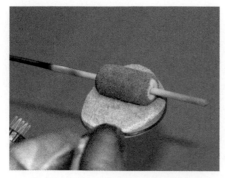

1— Make a bead of any shape and color. Scoop enamel powder into a metal spoon and roll the bead in it until the entire surface is covered.

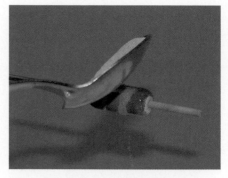

2— Melt the enamel completely into the bead until you have a smooth surface.

3— Apply the next layer in a second color of contrasting enamel. You can apply this the same way as before, or you can angle the spoon *over* the bead and tap it on the bead to create stripes. Melt this layer into the bead surface.

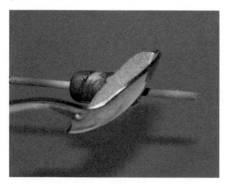

4— Add a third color if desired and melt it in.

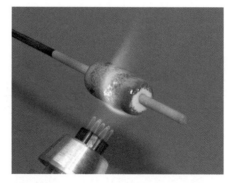

5— Hold the bead in the flame about ¼" from the tip of the torch. Keep an eye on the surface of the bead and after a second or two you should see it start to boil.

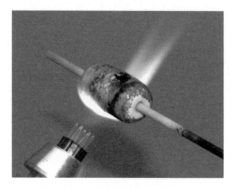

6— Continue to turn the bead and boil as much of the surface as you want to get the desired pattern.

7— The finished boiled enamel bead.

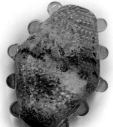

Hot TIP

A reducing flame (a more gas-rich flame) will create darker colors. Longer boiling will allow the bottom color layers to pop through to the surface.

Etched Window Bead —*Alethia Donathan*

This technique requires a heavily encased bead with an interesting core. The core can be dichroic, metal, twisties, etc. Leave the bead on the mandrel after annealing. Clean the bead with rubbing alcohol or white vinegar.

1— Make a pattern by wrapping a thin strip of paper around the middle of the bead. Mark and then cut the paper where it meets. Measure the strip and divide that length by the number of windows you would like in the bead. Mark the divisions and then make holes with a small paper punch or pointed tool. Tape together and slip over the bead.

2— Use a permanent marker to fill in all the holes. Remove the paper pattern from the bead without smearing the dots.

3— Dip the eraser end of a pencil into a pool of white or wood glue.

4— Press the glue covered eraser onto your bead, guided by the marker dots.

5— Bead with glue dots applied.

6— Let the glue dry overnight. Remove any exposed separator from the mandrel. (If you don't want to put your mandrel in the etching solution, remove the bead and put it on a bamboo skewer or fish line.)

7— Etch the bead according to the directions on the etching solution. This bead was in the solution for 5 minutes. Remove any remaining glue by soaking the bead in warm water.

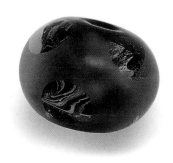

Aladdin Bead—*Diana East*

1— Make a pale transparent cylinder bead and add a few small squares of dichroic glass to the surface in a random fashion. Build the cylinder up into a large oval by adding more transparent glass, using streaks of color to suggest sky. Flatten the bead into a tabular shape.

2— In separate steps, sift three to four colors of enamel over the bead so that it looks darker at one end and gradually lightens as you move toward the other end.

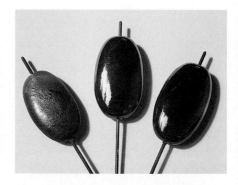

3— Fume the entire surface of the bead with gold. Diana likes to use gold casting grain on the end of a quartz rod.

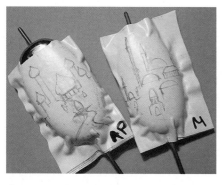

4— Apply vinyl tape over the surface of the bead as smoothly as possible, avoiding air bubbles. Draw a design on the vinyl with a pencil.

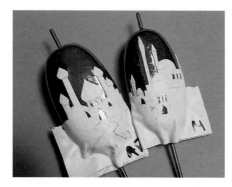

5— Using a sharp blade, expose all the areas that are going to be removed by sandblasting.

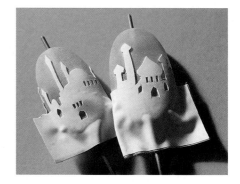

6— The sandblasted bead will look like this. (This bead was blasted with 220 grit aluminum oxide.)

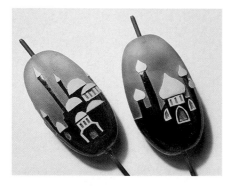

7— Cut away the vinyl tape in all the areas where you want the gold fuming removed. Put the bead into etching solution until all the exposed gold has disappeared.

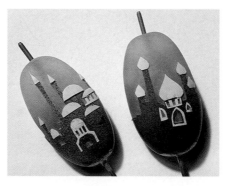

8— The etched bead will look like this. Remove the remaining vinyl tape. Rub the bead lightly with mineral oil to help it resist fingerprints and give it a slight sheen.

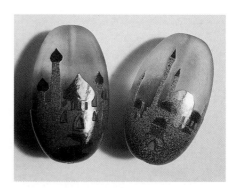

9— Finished Aladdin beads

Sandblasting Variations –*Diana East*

Blasted Bars Bead

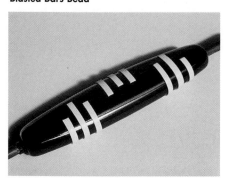

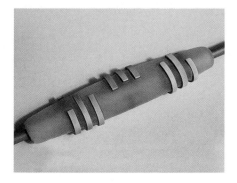

3— The finished bead incorporated into a graceful bracelet.

1— A clear bead has been completely covered with blue enamel and then fumed with gold. Vinyl tape strips were then applied to the bead.

2— The bead has been sandblasted. Note that the blue enamel shows through the bead, creating another dimension.

Murrini Core

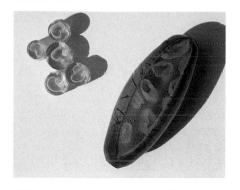

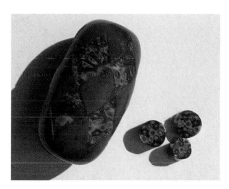

This bead has a murrini core with a solid covering of enamel and a light trailing of stringer. The blasted window allows you to see the core.

This bead has a murrini core with a solid covering of enamel. A diamond pattern has been blasted in the enamel to expose the patterned cane underneath.

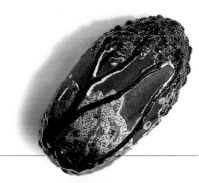

Moonlit Ruins Bead

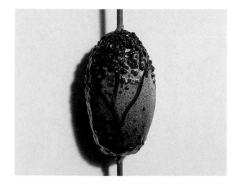

1— This design starts out just like the Aladdin bead except that the enamel does not need to go all the way to the top of the bead. Branches and leaves have been added with black stringer and frit.

2— A vinyl mask has been applied and cut out. A liquid resist was then applied over the branches and leaves. Diana likes to use liquid lead lines, a product used to make simulated stained glass, as the resist for the branches and leaves.

3— The bead after sandblasting.

Decal Button—*Mary Gaumond*

1— Make clear cabochons by nipping ¼" thick pieces off the end of a large diameter clear rod. Heat these nipped pieces in a kiln until they round over. Fire them on high fire kiln shelf wash or ceramic paper to help prevent sticking.

2— Cut a piece of dichroic glass and black or other dark colored sheet glass into squares the size of the cabochon bottom. Nip off the corners to create rough circles.

3— Choose a decal for the button. Many ceramic and fused glass suppliers carry high fire decals. These are water decals that you just soak in water, slide off and place on the glass. Mary has her decals custom-made so that she can design them herself and get exactly what she wants.

4— Soak the decal, slide it off the backing sheet and place it on top of the dichroic glass. Let it dry. Stack the three parts with the black on the bottom, the dichroic in the middle and the cabochon on the top. Fire these parts in a kiln until they are just stuck together (tack fused). This will eliminate an awkward assembly step in the torch.

5— Bring the tack fused pieces up to about 1000°F in your annealer. Pull the assembly out with a large tweezers and gently introduce it into the flame. Attach a glass rod (punty) to the back side. Try to work quickly so the tweezers don't get too hot and stick to the glass.

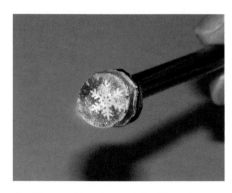

6— Your assembled glass stack should now be firmly attached to the punty rod.

7— Heat and shape the assembly until you have a smooth domed surface, using a button or marble mold.

8— If necessary, use a flattening tool to make the edges even.

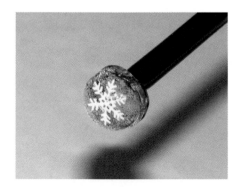

9— The finished button shape.

10— To finish the button back, transfer it to another punty. Do this by attaching a thick piece of clear stringer to the front of the button.

11— Melt the punty rod off the back of the button.

12— Use a pliers or tweezers to remove any remaining glass from the back punty.

13— Heat and flatten the back of the button.

14— Make a wire loop with crossed ends for the button shank. 17 gauge nichrome wire was used in this example, but 16 gauge copper will also work.

15— Heat both the wire and the back of the button. Add the wire loop by pressing the two parts firmly together, leaving only the loop exposed and the crossed ends embedded in the button.

16— Grasp the wire loop with a pliers and melt off the clear punty from the front of the button. Use a tweezers to remove as much of the remaining clear punty as possible.

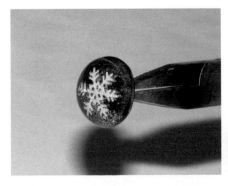

17— Heat and reshape the front of the button to remove all traces of the punty.

Linear Thin Casing —*Larry Scott*

Larry learned this technique from Loren Stump. Linear thin casing is an efficient way to add glass to a cylinder, or similar shape bead or gather. It involves heating the end of a rod until the tip is very molten and then using the relatively cool rod behind the gather as a pusher to spread the molten glass in a thin layer along the length of the bead. This is a straightforward way to get a nice, smooth transparent layer of casing on the bead.

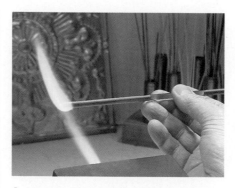

1— Heat your casing rod by holding it parallel to the table. This allows you to get a small gather of hot glass at the end of the rod while leaving the rod behind it stiff. If you hold the rod vertically, heat rises up through and beyond the gather. By holding it horizontally, very little heat will be conducted along the length of the rod. This will be important when you start applying the glass.

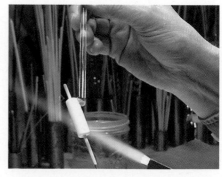

2— Heat the end of your rod until you have a gather the size of a large pea. Hold the rod nearly parallel to the bead and push a stripe of glass along its length, starting at the top of the bead. The bead needs to be relatively cool so that it does not distort while you are adding the hot glass stripe.

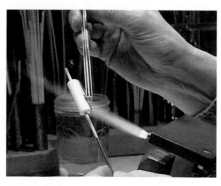

3— Stripe the whole length of the bead from top to bottom. By pushing quickly, you will get a thin layer of casing. If the gather is hot enough, it should easily spread along the length of a bead 1¹/₂" long or longer.

4— Continue striping around the bead, butting up each new stripe tightly against the last one. Make sure that the gather is very hot and that you move quickly, pushing the glass from behind. This will minimize trapped air and make an even, thin coating of glass.

5— The striping is almost finished.

6— When the striping is complete, begin melting it in. Start at one end and gradually move to the other end as the casing melts and smoothes out. This allows any trapped air to be squeezed out the end as you go.

7— The casing is smoothing out and almost finished. If the casing is a bit uneven at the ends, you can now dab some extra glass there. The finished bead should have a bubble-free, thin, beautiful casing.

A cased core and the finished bead after the core has been decorated.

Twisted Twistie Bead —*Cindy Jenkins*

1— Make a twistie from two regular-sized rods and one thick stringer of a highly contrasting color. This helps to target where to twist the lines later. Apply this twistie around the equator of a round bead.

2— Wind the twistie all the way around until the edges meet. Bend the twistie down at a right angle and leave it hanging.

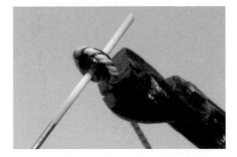

3— Using a nipper, cut the hanging twistie off as close to the seam as possible.

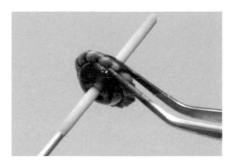

4— Use a tweezers to remove any extra twistie at the seam and, if needed, to straighten the area where the ends meet.

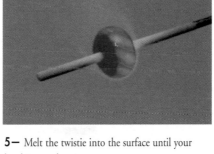

5— Melt the twistie into the surface until your bead is round again.

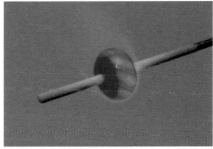

6— Use a short length of $^1/_{16}$" diameter stringer to twist the melted-in twistie pattern. Let the entire bead cool until the glow has completely disappeared. Start your twist pattern at the seam where the two ends of the twistie came together. Spot heat this area for a few seconds until it has a bright glow. Come out of the flame, quickly touch that area with the end of your stringer, and twist about half a turn. Let it cool and then snap the stringer off by wiggling it back and forth.

The contrasting color in your twistie will help identify the next place to twist. Aim for that contrasting color band as you continue twisting around the bead. (When learning this technique, you may find it easier to twist only every other color band.)

7— A view of the twisted area.

8— The finished twisted twistie bead.

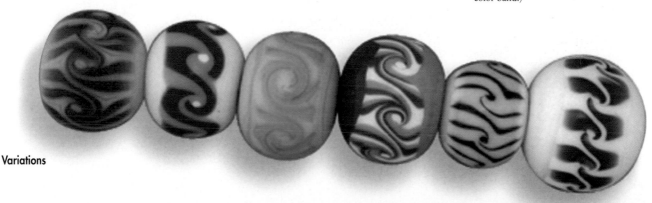

Variations

Fun With Palladium and Dichro
—Leah Fairbanks

Most beadmakers are familiar with the shiny, glitzy properties of dichroic glass but not everyone is as familiar with palladium leaf. Palladium is a member of the platinum metal family. It is a silvery color when you buy it but can produce many colors when it is left on the surface of a bead and then exposed to low levels of heat. It works wonderfully at fusing temperatures (1350-1550°F). The beauty of palladium is that unlike silver and gold, it can withstand as much heat as you can give it.

1— Lay some strips of palladium leaf on a dark surface such as a graphite marver and then lay pieces of dichroic glass over both. You will see how different the dichroic looks on each background. Pick a piece with good contrast.

2— Make a dark colored base bead. A long tapered cylinder works well.

3— Sandwich some palladium leaf between sheets of paper and cut it into strips. Alternately, use a pair of tweezers to tear the palladium leaf into random pieces. Heat your base bead to an all over glow and roll it over the palladium. You can also pick up the pieces with your tweezers and add them to the bead.

4— Marver the bead a bit to burnish the palladium down onto the bead surface. Your bead should have some good-sized areas that are not covered by the palladium.

5— Heat a piece of dichroic glass from the uncoated side until it is hot enough to stick to the bead. This piece can be large enough to cover the bead entirely or it can be just a strip spiraled around the bead. Make sure you cover both the bare and the palladium-covered parts of the bead.

6— Use a tool to heat and press down all the raw edges of the dichroic glass so that the coating does not crawl to the surface.

7— This shows the color difference between the dichroic over palladium and over the dark glass of the base bead. You can finish shaping and fire polishing or add a casing layer if you like.

8— The finished palladium and dichro bead. This makes a great base bead for frit and flowers.

Dichro Core Bead –*Pati Walton*

Cut your dichroic sheet glass into small rectangular pieces about ¹/₄" longer than the length of your bead. A 1¹/₄" width wraps nicely around a narrow cylinder.

1— Make a thin cylindrical bead, ¹/₄" shorter than the length of your dichro piece. It takes a bit of practice to get the dichro square to fit perfectly with the base bead. Using a stamp tweezers or a flat nosed pliers, hold one edge of the dichro piece in the flame. Be sure that the dichroic coating is facing away from you, with the flame hitting only the uncoated side of the glass or you may get scum.

2— Heat the base bead while you continue to heat the clear side of the dichro. With the edge of the dichro exactly parallel to the length of the bead, touch the dichro to the bead.

3— The piece of dichroic glass should now be stuck to and hanging off one side of the bead like a sheet on a clothesline.

4— Continue to heat the dichro glass piece that is hanging down. Gradually push it down and roll it around the bead with pliers.

5— At this point, the edges should be fairly close to meeting. If your piece is a little too big, use a tool to push it in a bit. If it is too small, use a tweezers to close the gap. In the picture, the gap has been partially pulled together. If the gap is too big to close, you can add an extra sliver of dichro glass in the gap but this is not the most desirable solution. Next time try to get the base bead the proper size.

6— Using a pliers or another tool, push the edges of the dichro glass down toward the hole of the bead on both sides. If you don't seal the coating down tightly to the bead, the coating may float up to the surface and form scum.

7— Heat, smooth, and shape the entire bead. Now you can apply whatever decorative elements you wish.

If you still have a visible seam, pull one edge over the other to make a decorative wave pattern. You can also put a design element over the seam, like a stem or piece of seaweed.

Reduced Silver Bead —*Lisa St. Martin*

1— Make a base bead of any shape you like. For a first try, use cobalt blue or black glass as they tend to react strongly with silver leaf.

2— Roll the warm bead over a piece of silver leaf large enough to cover the entire bead. Have some extra pieces of silver handy, in case you need them.

3— Burnish the silver leaf onto the bead by rolling on a marvering tool.

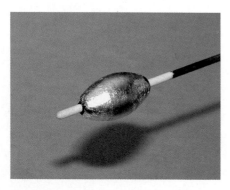

4— Gently heat the bead until the silver becomes shiny.

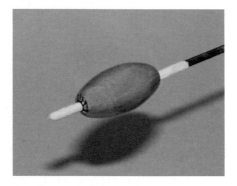

5— Adjust your torch to a reducing (gas-rich) flame. Heat the bead until the silver reacts with the base bead and forms a ghostly silver iridescence.

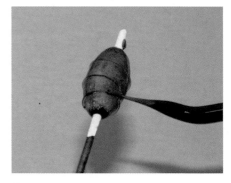

6— Decorate on top of the silver. Consider dots, trails, or any other technique you wish. Be sure to leave most of the reduced silver showing. When you're through decorating, give the bead another shot of the reduction flame if necessary.

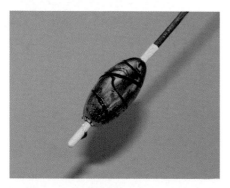

7— You can stop at this point, or you can encase your design. If you're going to encase the bead, first melt the surface design in flat.

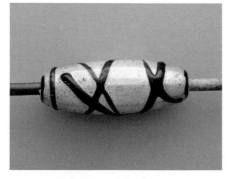

8— Unencased reduced silver bead.

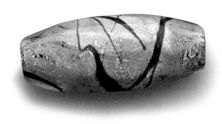

Encased reduced silver bead.

Silvered Stringer Bead —*Jennifer Geldard*

1— Make a cylinder bead and draw a pattern on it with ivory stringer. The stringer design should not have any open areas larger than about $1/4$".

2— Fill any gaps in the design with dots, lines or small squiggles.

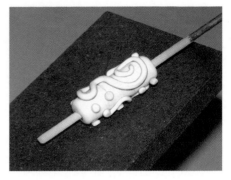

3— Leaving the stringer design raised, heat it and lightly marver it to assure that all the raised decoration is at the same height.

4— Gently heat the surface of the bead and roll it over a strip of silver leaf. The leaf should be wide enough to cover the entire width of the stringer pattern and long enough to wrap completely around at least once. Roll gently on your marver to burnish but don't push the foil into the gaps.

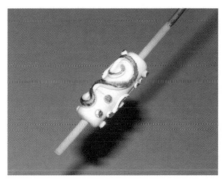

5— When you go back into the flame, the silver leaf will mold itself over the stringer and quickly burn quickly away from the empty areas, leaving the base bead itself plain.

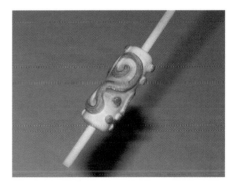

6— At this point, you can melt the silvered stringer in as much as you like. Because an ivory base was used here, the silver reacted somewhat with the entire bead. Ivory glass reacts strongly with silver.

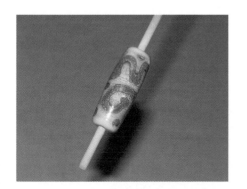

7— The stringer is completely melted in.

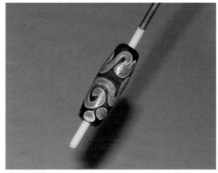

8— The same ivory stringer design as above but with a dark base bead.

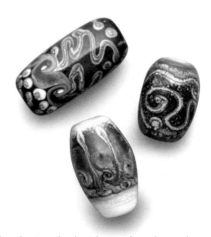

Silvered stringer beads with enamel powders used on the background.

Silver Wire-Wrapped Bead

—Lisa St. Martin

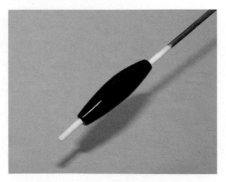

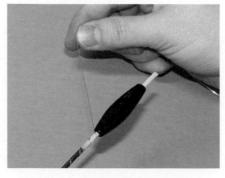

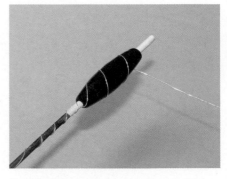

1— Make a long tapered cylinder bead. Heat the finished bead so that it has a slight glow. Come out of the flame.

2— Cut a piece of 28ga fine silver wire to approximately 18" in length. Firmly grip 4-6" of the tail end of the wire against the mandrel with your thumb. Wrap the wire a few times around the mandrel to anchor it.

3— Wind the wire all the way to the end of the bead in a spiral pattern.

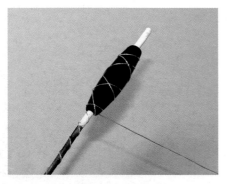

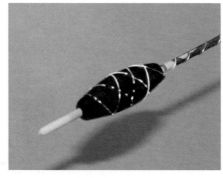

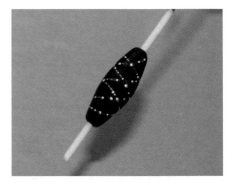

4— Wind the wire back toward where you began. The wire will form an "X" pattern as the spirals cross each other. Continue winding until you run out of wire.

5— Immediately put the bead back into the flame and start heating it. The wire will start to break up and form lines of dots if you heat it quickly enough. Slowly heating it tends to leave the wire more intact.

6— Your bead should now have either silver lines or little lines of small silver dots. Depending on the color of your base bead, there may also be a trail left behind where the silver reacted with the glass to create a new "silver-stained" color. After the silver has achieved the look you want, marver the bead a bit to make sure the silver is properly adhered.

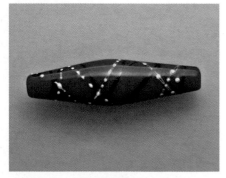

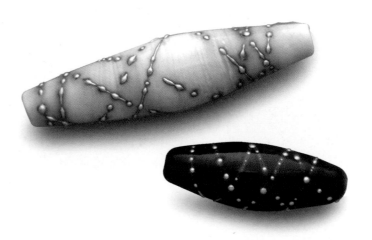

Variation put some fine glass trails on your bead before adding the silver wire.

Silver Foil Fish Bead —*Sage*

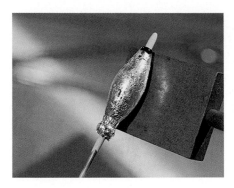

1— Make a twistie using transparent colors. For this bead, Sage has used four colors in her twistie. Make a vessel shaped bead and cover it with silver foil. Be sure to burnish the silver down onto the bead really well before proceeding.

2— Coil the twistie around the entire bead, keeping the silver out of the flame as much as possible. As soon as you finish coiling, go back to where you started and reheat the coils. Continue heating along the coils until they are completely melted into the bead surface.

3— Smooth the whole bead surface out with your paddle.

4— Flatten the bead form with your mashers without squashing it too flat. The sides of any bead need to be at least as thick as the mandrel you are using.

5— Begin to build the fins and tail by adding twisted cane to those areas. Build them up more with stripes of clear glass on top of the twisted cane.

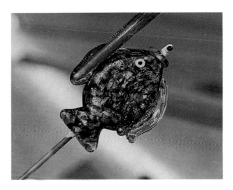

6— Use tweezers to shape and pull the fins and tail. Add white spots for eyes on each side and then add a small black pupil dot on top of that.

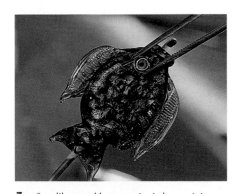

7— Sage likes to add concentric circle murrini on top of the eyespots. Her murrini have a transparent center that the eyespot shows through. Start by heating the eyespot. Then pre-heat the murrini by holding it with tweezers and waving it through the flame. (Don't heat the murrini so hot that you fuse it to the tweezers.) Carefully place the murrini on top of the eyespot. Heat it enough to fully fuse it and remove any undercuts.

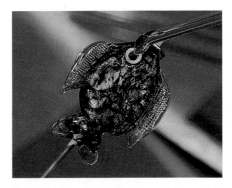

8— Add a drop of clear glass on top of the murrini if you like. This creates a lens effect for further fishiness.

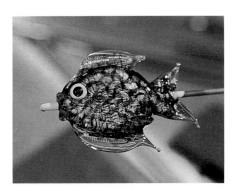

9— The finished silver foil fish bead. Be sure to evenly heat the whole fish before putting it into the annealer.

Hollow Bead —*Heather Trimlett*

Hollow beads are some of the most rewarding and maddening beads to make. Once you get the technique down, they are lots of fun.

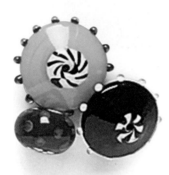

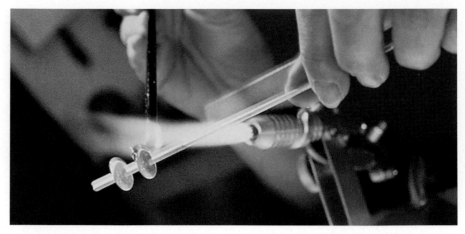

1— Make two very small beads on your mandrel leaving about ³/₄" between them. This will determine the size of your final bead. For your first attempt, don't place them too close together or too far apart. Either way makes the process more difficult. Build the beads up into disks by adding more glass around the equator of each small bead.

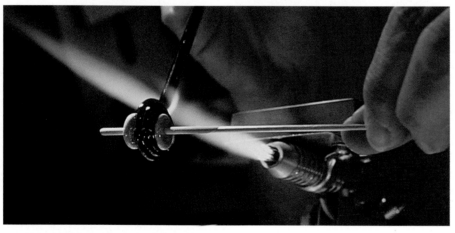

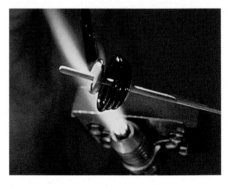

2— As you build up the disks, put each successive layer just slightly inside the last one so that the disks begin to lean toward each other. Alternating disks as you build these layers helps keep everything warm and prevents cracking.

3— Notice the cup shape that has been formed with the blue glass. Don't expect your first try to look this neat. It will work anyway as long as you don't leave any holes.

4— When you have built up both sides until they meet, put a final wrap around the middle to bridge the two sides together. Check the whole thing over really well, keeping a sharp lookout for any holes. Patch these holes before going on to the final heat.

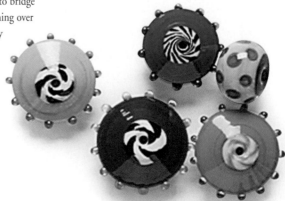

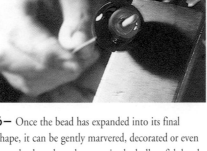

5— Heat the bead with your flame directed at its center. Remember that glass follows the heat. If you direct your flame too much toward the edges, the middle will flatten out and could collapse. The bead will get a little smaller at first as the coils melt into one smooth surface. Once the bead is smooth, it will start to puff up from the expanded air on the inside. A hole anywhere in the structure will allow the air to escape, and the bead will collapse in on itself.

6— Once the bead has expanded into its final shape, it can be gently marvered, decorated or even completely reshaped as seen in the hollow fish bead instructions on page 116.

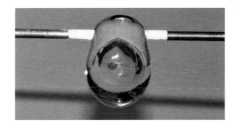

Bonus Tip If your first hollow beads come out a little wonky, heat one side and let it droop into an off-center shape. These beads make great pendants.

If you're still having trouble making a hollow bead, here are a couple more ideas.

Some people prefer to use tools to coax the disks toward each other. You can gently push them toward each other with a tweezers, rake or paddle.

Pam Dugger likes to build three or four bridges across the gap between the two disks. This helps to stabilize the disks during the last steps. You can now fill in the gaps between the bridges with less chance of collapse.

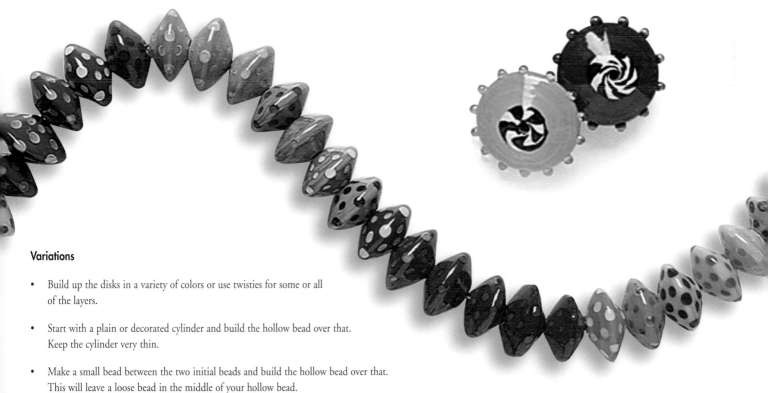

Variations

- Build up the disks in a variety of colors or use twisties for some or all of the layers.

- Start with a plain or decorated cylinder and build the hollow bead over that. Keep the cylinder very thin.

- Make a small bead between the two initial beads and build the hollow bead over that. This will leave a loose bead in the middle of your hollow bead.

Hollow Fish Bead –*Ofilia Cinta*

Ofilia learned to make hollow fish beads from Pam Dugger and gratefully acknowledges Pam as a mentor. These are a bit more challenging than plain round hollow beads but allow for more artistic expression.

Start by making a round hollow bead.
(See instructions on page 114.)

Ofilia likes to use a lot of different transparent colors in a random fashion to build up the disks for the hollow bead.
She calls this staining.

1— When the hollow bead is all sealed together, add some stringer squiggles. Ofilia calls this *scribbling*.

2— Smear some patches of color over the surface.

3— Add a variety of frits to the surface of the bead. Ofilia calls this *spotting*.

4— Melt all of this surface decoration in. At this point, the bead will start to puff itself out into a rounded form.

5— Look for areas that you want as sides of the fish. Lay your hollow ball on a marver and use a paddle to gently flatten the ball into a disk shape. Don't squash it so flat that the sides touch the mandrel.

6— The flattened disk shape.

7— Concentrate your heat on one end of the flattened bead. When it is glowing red hot, put the mandrel between your palms and quickly rotate back and forth. This will start to elongate the bead. Repeat this step until you have the desired tail shape.

8— Heat the other end and elongate it to form the head of the fish.

9— Add eyespots to both sides of the fish.

10— Add a fairly dark color for the iris. Put a clear or pale colored transparent dot on top of this.

11— Add a big dot to the head end of the fish for the lips. Using a razor tool, impress a line in the dot to form the lips. You can also use a raking tool to pull the corners of the lips up or down.

12— This photo shows the finished lips.

... continues on following page

Ofilia's Color Secrets

Ofilia adds lots of tiny spots of color on top of the iris dot before she puts the clear or pale transparent dot on top. Using stringer, she will add up to six colors, including aventurine for sparkle.

For the lips, Ofilia adds some frit on top of the first dot and then covers that with another transparent dot. She also often adds frit in between the layers of color in the fins for extra intrigue. These little extra steps add a lot of complexity to the overall design and, over time, reveal themselves to the owner.

13— Build up nubs for the fins and tail. Make sure these are well attached.

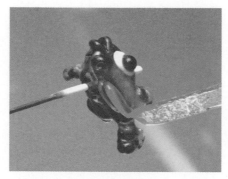

14— Keep changing colors as you build the nubs higher. Using opaque glass at the base and transparent for the upper layers works well.

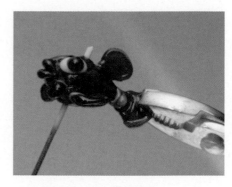

15— Start shaping the fins. Ofilia likes to use an ordinary slip-joint pliers to do the initial flattening and pulling. This adds some texture while pre-shaping the fins. You can also snip the tail in half with scissors.

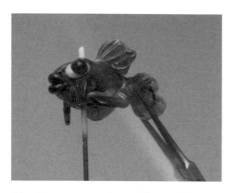

16— Use a tweezers or long needle nose pliers to continue refining the shape of the fins and tail.

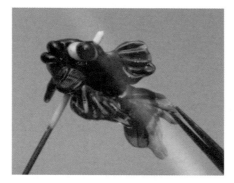

17— Keep heating, sculpting and manipulating the fins and tail until you are happy with the overall shapes. Throughout this whole process, you must stop frequently and add heat to the parts that you aren't working on. The fins, and even the eyes and lips, can pop off if they get too cold. The body of the fish can also crack if you're not careful to keep it heated.

18— Add the pupil last, using a black stringer. If you put the pupil on earlier, it tends to get bigger and bigger as you work. Before you put the fish in the annealer, spend some time giving the whole structure a good heat, paying particular attention to thin parts and joints.

If your initial eye dot placement is off, you can cock the fish's head off to the side to help disguise it.

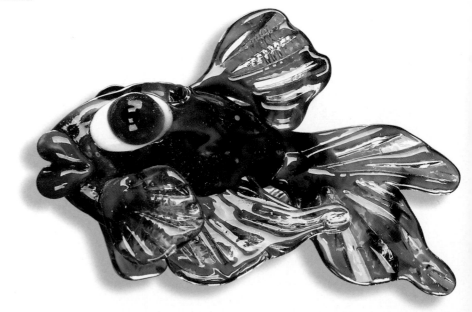

Double Helix Twist Cane —*Al Janelle*

1— Apply a stripe of color to the last inch of a clear rod using a stringer.

2— Add a second stripe exactly opposite the first one. These stripes can be the same color or two different colors. If you use transparent colors, use the darkest ones available.

3— Use a razor tool to straighten the stripes if needed.

4— Add clear glass to both sides of each stripe. This prevents the stripes from spreading. Completely fill in the valley between stripes so that the cane becomes round again.

5— Melt the structure down until the cane is smooth. Add another layer of clear all the way around. This will cover up the color stripes.

6— Continue to heat and marver until you have a smooth surface.

7— Add a Pyrex punty rod to the end of the structure. Nip off the clear cane. Heat and add another punty to the nipped side.

8— Get the whole structure evenly hot. You can test for this by coming out of the flame and bending the structure. If it bends easily, it is ready to pull. Reheat and straighten.

9— Pull a little and then start twisting. As the glass begins to cool, continue to twist as quickly as possible with your hands moving in opposite directions.

Ribbon Twist Cane —*Al Janelle*

1— Heat a white rod until it forms a ball about the size of a grape.

2— Squash the ball to form a paddle shape about ⅛" thick.

3— Use a graphite paddle to square up the sides.

4— Cover one side of the paddle using a strong color such as cobalt blue.

5— Cover the other side of the white paddle with clear glass.

6— Cover the edges of the paddle with clear and then melt this whole layer of glass until smooth.

7— Continue adding clear glass until the structure is round again.

8— Add pyrex punties. Heat the whole structure evenly.

9— Pull and twist into a ribbon cane.

Complex Twist Cane Variations

—Al Janelle

Triple Helix

Milk Swirl over a White Core

Rainbow Lace

White Lace

Double Helix with Threads

Ribbon Twist with Ends Capped

Ribbon Twist with Transparent Overlay

Transparent Overlay with Floating Threads

Custom Ribbon Twist

Custom Double Ribbon Twist

Rainbow Ribbon Twist

Ribbon Twist with Ends Capped and Threads

Rainbow Latticino Cane —*Lea Zinke*

1— Prepare by cutting at least six pieces of rainbow-colored glass rods into ³/₄" lengths, two each of three colors. (It's a good idea to have a couple of extra pieces in case you drop or crack one.) Heat the end of a white rod until it is about the size of a small grape. Use a masher to flatten it into a paddle-shape about ¹/₈" thick and ³/₄" wide.

2— Apply the first pre-cut rod to the center of the flattened paddle with a pliers. This rod should be applied perpendicularly to the rod handle. This example uses transparent rod but opaque is fine to use too.

3— Add the same color rod to the same spot on the opposite side of the paddle.

4— Add a second color, butting it up to the first color.

5— Add the same color to the opposite side in the same position.

6— This shot shows the paddle with the third color added on both sides. As you get better at this, you can add more than three colors along the length of the paddle.

7— Add goldstone stringer to the white edge on each side of the paddle. Black filigrana also works well.

8— Heat, smooth and shape the paddle.

9— Add clear glass to the end of the paddle so that it sticks out about ¹/₂" and has a tapered shape.

10— Heat the end of a stainless steel chopstick to a red glow.

11— Plunge the chopstick into the warm, clear end glass about ¼". Move the chopstick up, down, left and right to make sure that it is well anchored .

12— Use nippers to clip off the white rod flush with the end of the paddle.

13— Add clear glass to the other end and insert a second chopstick. Flat chopsticks can also help prevent internally twisting more intricate picture canes.

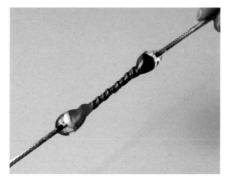

14— Evenly heat the whole bundle and then start to twist it out.

15— Continue rapidly twisting and gently pulling until the twisted cane is complete.

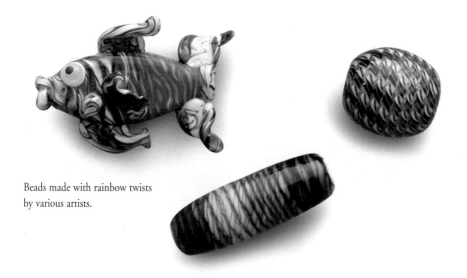

Beads made with rainbow twists by various artists.

- Despite the name rainbow cane, try using different shades of a single color.

- For less abrupt transitions between colors, flatten the center color down a bit first and then allow the adjacent colors to overlap it slightly.

Floral Cane *–Kristen Frantzen Orr*

Kristen is known for her gorgeous floral beads. Here is one of her secrets for creating incredible detail.

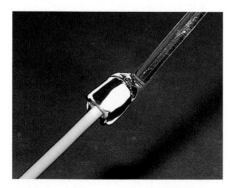

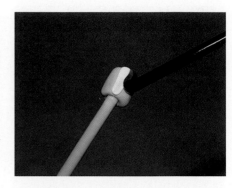

1— Make a short squatty cylinder on the end of an opaque rod by melting a grape size ball of glass and then using large squashers to coax it into a cylinder shape. For this example, Kristen is using periwinkle blue.

2— Add alternating stripes of white and transparent cobalt blue. Stripe the lines on by pushing with your rod held at a tight angle to the periwinkle rod. This helps prevent air bubbles by squeezing the air out as you go.

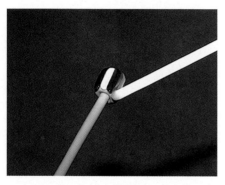

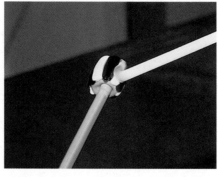

3— Make stripes all the way around. Make sure that each new stripe butts up against the last one. Heat and reshape the cylinder. Even up the end if necessary.

4— Go all the way around one more time, using the same colors on top of each other for the next layer.

5— This is what the layered cane should look like when viewed from the end. By striping from the end of the bundle down toward the rod, you will always have a clear view of the pattern from the end as you go along. This becomes more important as the canes become more complex.

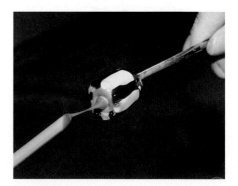

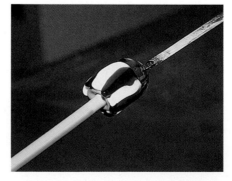

6— Cap the end of the bundle with a generous amount of clear. Make sure that the clear cap touches all of the colors so that the bundle will pull out correctly.

7— Heat the clear cap and a stainless steel chopstick. Insert the chopstick into the clear cap until it almost touches the bundle. Quickly move the chopstick up and down and then left to right to be sure of a good attachment.

8— Using the chopstick as a handle, flame cut the periwinkle rod off the other end.

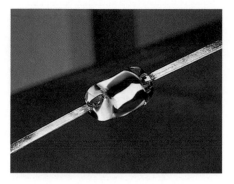

9— Heat and reshape the bundle. Add a thick cap of clear glass and attach a second chopstick.

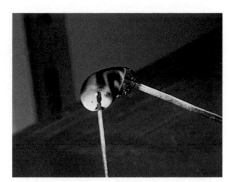

10— Evenly heat the bundle. Rotate about one stripe width on the left side, slide across the middle and then rotate another stripe width on the right side. If it is helpful, talk yourself through this step by saying "turn, slide, turn, slide." When the bundle is molten enough to pull, you will be able to bend it in the middle. Do not actually fold it; this is just a test to determine if it is ready to pull. When it bends easily in the middle, straighten it out and give it one last overall heat. Come out of the flame.

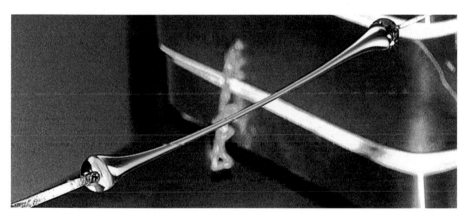

11— Wait a few seconds to allow a skin to form on the outside of the glass. Pull slowly until the cane has been drawn out to about the thickness of a wooden toothpick. Nip the cane into approximately one-foot lengths. Quench the chopsticks in water and remove the waste glass with pliers.

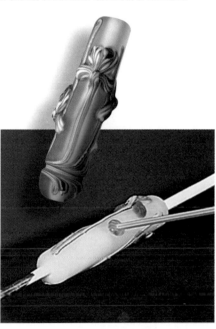

12— You now have a striped cane ready to apply to the surface of a bead. Kristen likes to spend a whole day pulling canes so that when she's ready to make beads she will have a variety to choose from.

13— By heating only the tip of the cane, and working just outside of the flame, you can use the cane like a paintbrush to create leaves, petals and stems.

Keep a diagram of your color choices and attach a small sample bead. This allows you to create a library of choices for future use.

Flat stainless steel chopsticks make great punties for pulling. You can find them at Korean grocery stores.

Stamen Cane—*Various Artists*

Folded Filigrana

1— These very useful canes can be used in your floral beads to add a touch of realism. For this technique, heat and fold a filigrana rod over onto itself, forming a U-shape.

2— Heat and fold bend the rod back on itself again.

3— After folding several times, heat the whole structure evenly and pull it into a medium sized stringer.

Stringer Stripes

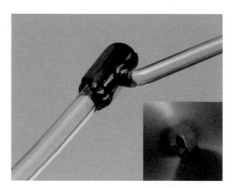

1— Stripe a colored stringer onto the end of a clear rod.

2— Continue adding stringer stripes all the way around the rod, leaving spaces of exposed clear glass.

3— Encase the striped rod with additional clear. Heat and pull into a medium sized stringer.

Applied Filigrana

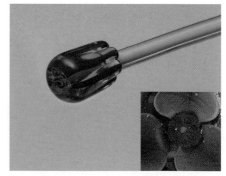

1— Cut filigrana rod into 1" lengths. Use a pliers to pick them up and attach lengthwise to a filigrana rod of a contrasting color. In order to stick together, both parts need to be slightly glowing but not floppy.

2— Continue adding the precut pieces of filigrana around the central rod.

3— When the entire central rod has been covered with filigrana pieces, heat and pull it into a medium sized stringer. No additional casing is needed with filigrana rods.

Floral Bead —*Peggy Rose*

1— Select an opaque and a transparent color for your flowers. Make a bead out of a coordinating color and decorate a bit if you like. This decoration could be done with metal leaf, dichro, frit, stringers etc. This example has a twistie and aventurine stringer core. Encase the core with clear or a pale transparent color.

2— Apply 3-5 dots of the opaque color in a circle. Odd numbers seem to work the best. Leave a space between the dots approximately the same size as the dots.

3— Melt the dots in just a little and use a razor blade tool to crease the dots from the center of the flower outward. This will create the look of a vein in the middle of the petal. Keep a cup of water handy to cool the tool in between dots.

4— Put transparent dots on top of the opaque, razored dots.

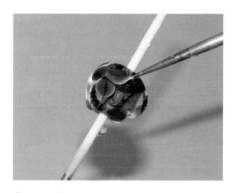

5— After all the transparent dots have been applied, melt everything down flat. You can then use a rake or pick to pull the tips of each dot out if you want the petals to be pointed.

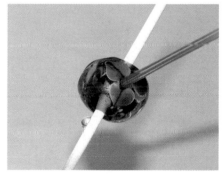

6— Use a pre-made stamen cane to finish the flower. (See stamen cane technique on page 126.) Heat the flower center to a good glow, come out of the flame and then quickly plunge the stamen cane into the heated center. Let it cool a bit and then wiggle the stamen cane until it snaps off. The center of the flower can also be finished with a simple dot, a bubble dot, or a small millefiori.

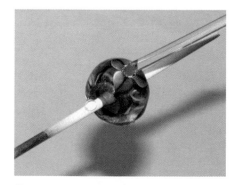

7— Place a small dot of clear on top of the stamen cane. This will magnify it and make the detail show up better.

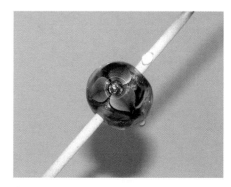

8— The finished floral bead.

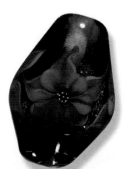

Flower Murrini Cane —*Eric Seydoux*

1— Make a little sketch of the finished murrini cane and prepare your colors accordingly. Pull some stringers in appropriate colors. For this example the stringers will be dark red and yellow.

2— Case a black rod with red and then with yellow. When red glass is hot it looks just like black glass so you can't distinguish the two colors in the above photo.

3— Heat up the cased shape and jam it into a mold to create ribs. This is a homemade mold but commercial ones are available.

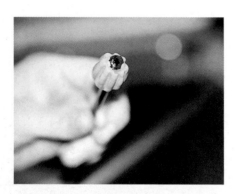

4— The mold pre-shapes the cylinder for you.

5— Lay red stringers into the grooves created by the mold.

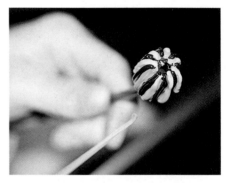

6— Build up red and yellow stringer stripes alternately.

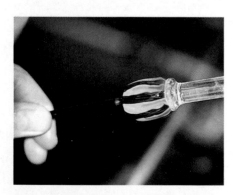

7— Attach the end of the bundle to a Pyrex punty that has a slightly flattened end. The bundle should now be much more stable.

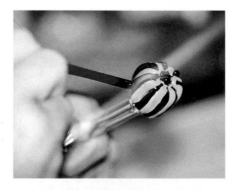

8— At this point you can switch from stringers to full size rods as you continue to build up the alternating stripes. Add more red glass all the way around.

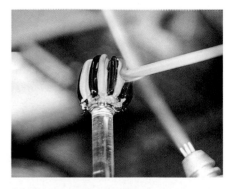

9— Continue adding more yellow and red until the bundle is the diameter you want. Think small for your first few tries.

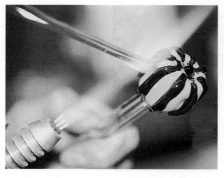

10— Add some transparent glass over only the yellow. This will allow the red petals to appear longer than the yellow petals in the finished piece.

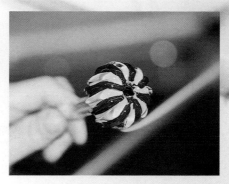

11— An end view of the finished cane.

12— Add a Pyrex punty to the other side of the bundle. Heat the whole thing as evenly as possible and slowly pull until it reaches a useable diameter. $^1/_4$" is a good size.

13— The finished cane ready to be nipped up into short sections.

14— Add the murrini chips to a bead. By making a simple bead like this right away, you will be able to see immediately what the murrini will look like.

15— Compare the finished bead to the original drawing. How did you do?

Hot
TIP

A simple optic mold can be made by hammering nails into a piece of wood in a circular pattern. The circle should be fairly tight at the bottom and slightly flared at the top (see step 3). Cherry is a good wood to use; it is dense and has little sap. Wet the wood before using the mold.

Bead-End Pattern Cane *–James Jones*

This is not intended to be a comprehensive step-by-step description of Jim's complex murrini making techniques, but rather an overview of how he is able to achieve such incredible detail in his beads. This page will give you an idea of how his bead end murrini are made. It should also create a real appreciation for how much work Jim does before he ever starts to work at the torch.

1– Cut strips of fusible sheet glass to size. In this example, there are 8 strips of black and 32 strips of ivory cut to 3" x ³/8", and 16 strips of black and 24 strips of ivory cut to 3 x 1¹/2".

2– Glue one skinny strip of black between two wide strips with all the edges lining up on one side and the wide strips coming together on the other side to form a wedge shape. Do the same thing with the ivory using two narrow strips between three wide strips.

3– Allow the glue to dry. Here is a side view of the wedges.

4– Stand the wedges on end to form a circle. Using rubber bands to hold them in place, insert the remaining narrow strips of ivory in between the black and ivory wedges in the circle. Use a little glue on the top outsides edges to help hold the whole bundle together.

5– This shows the bundle from the side. When the glue is dry, the rubber bands are replaced with wire. Thin stainless steel wire works well.

6– The bundle is heated in a top opening kiln to fusing temperature, picked up on a punty rod and then heated in a glassblowing glory hole (heating chamber). Before the surface of the bundle gets too tacky, the wire is snipped and pulled off. The bundle is then marvered, attached to another punty rod and pulled into lengths of cane. The cane is then cut into thin slices. This cane has a hole in the center, allowing it to be slid onto the mandrel to form a pattern on the end of the bead.

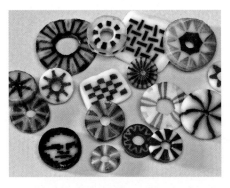

An assortment of murrini slices and bead end canes.

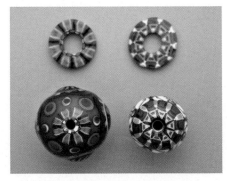

Two of Jim's unique beads shown from the end with their corresponding end slices.

Window Murrini Cane —*Mary Gaumond*

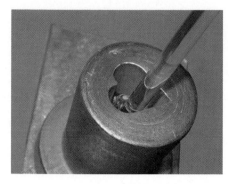

1— Choose an optic mold for the base design. Heat a clear rod until you have a small grape sized gather on the end. Check to make sure your gather will fit into the chosen optic mold. Push the gather into the mold all the way down, forcing it into the shape of the mold.

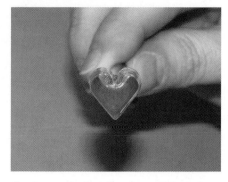

2— Remove the shape from the mold. A crisp heart shape has been created by the mold.

3— Fill in any valleys first. For the heart, go into the deep crevice at the top.

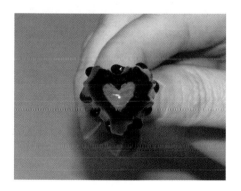

4— Continue adding casing around the heart shape until it is completely covered. Note that the end view of the shape still resembles a heart.

5— Add more casing to the low areas until the cane is circular. At this point, you can use another optic mold to create a framing pattern if you wish.

6— The second optic mold creates a new shape.

7— Use a contrasting color to encase your new shape. Because the circular mold creates no low spots, this example only required one final layer of casing color.

8— Add clear caps and punties to both sides of the bundle and pull. Don't let the diameter get too small; these are meant to be windows.

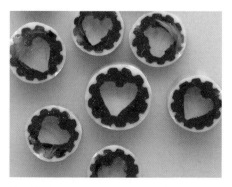

9— The finished canes. The clear window allows you to customize these murrini any way you like on your bead. Try placing them over a contrasting color, dichroic glass, metal, twisties or even another murrini cane. Ingenious.

Almost Easy Vessel — *Various Artists*

This vessel bead is a composite of techniques learned from many different artists. I admit that I frequently come up with "great ideas" that work wonderfully in my head but don't quite pass the torch test. With this one, though, I was able to go to the torch and execute the vessel almost perfectly the first time — and then again and again. I was thrilled.

1— One way to keep track of how much glass you use, and to increase repeatability in your beads, is to mark your rods in 1" intervals. A Sharpie marking pen was used. This tip came from Kim Affleck.

2— Build a thick cylinder shape about an inch long. Four inches of rod was used in this example.

3— Heat and melt the cylinder until it pulls itself into a football shape. This allows you to get everything centered. This tip is from Jim Smircich.

4— Add any kind of decoration that you like. This bead just has a simple spiral wrap made with a thick stringer.

5— Melt the decoration flush with the surface of the bead.

6— Holding the bead as vertically as possible in the flame, heat and rotate until the bottom starts to move down and form a pucker. This will become the bottom of the vessel. This part of the bead is also from Jim Smircich.

7— Taper the bottom of the bead with a marvering tool if necessary.

8— The finished bottom should look something like this.

9— Start the vessel lip by wrapping a bead over the top end.

10— Heat the lip to smooth it and form a good attachment to the body of the vessel.

11— Use a tool to crease the neck of the vessel for more definition if needed.

12— Add a guide dot to your mandrel to help with symmetrical placement of the handles.

13— Turn the mandrel until the guide dot is directly in your line of sight. Add a pilot dot to the lip of the vessel, aligned with the guide dot. Add another pilot dot on the body of the vessel, just below the one on the lip. Keep the dots about ⁵/₈″ apart for your first try. The three dots should form a straight line.

14— Turn the mandrel until the guide dot is completely hidden by the mandrel. Add your pilot dots to this side of the vessel. These dots should end up exactly opposite the first set of dots. Before heating them again, check to see if they are properly placed. If they are slightly out of position, you can use a pliers or tweezers to pop them off. If they're too well attached to easily pop off, you can heat and nudge them a bit with a tool.

15— The finished pilot dots should look like this. The pilot dot tip comes from Barbara Becker Simon.

16— Start building up the dots. Each additional dot should be slightly to the inside of the handle area. Your handles should be starting to look like this picture. This part of the handle technique is from Kate Fowle Meleney.

17— Keep adding dots, moving closer and closer to the center.

... continues on following page

18— The sides of the handles should now be approaching each other.

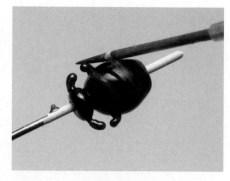

19— Use a tool to nudge the handles together until they touch or almost touch.

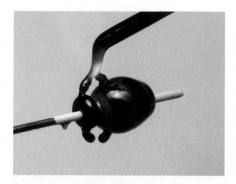

20— Add more glass to the gap to bridge the gap in the middle of the handle.

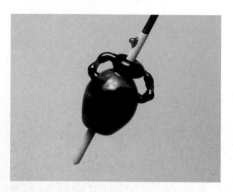

21— Your handles should now look something like this.

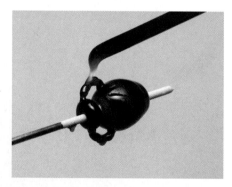

22— Fill out any skinny parts on the handles by adding glass as needed.

23— Have a pick or raking tool handy for this step. Start slowly heating and melting the handles smooth. The handles have a tendency to collapse when they are being heated. Be ready to insert your tool into the hole of the handle to maintain its shape.

24— The handles will thicken and smooth out as you continue to heat. Use a pick or rake to do any final shaping.

25— The finished vessel.

Decorated Core Vessel

—Barbara Becker Simon

Barbara makes such fun little vessels, you can't help but smile when you see them. She has graciously agreed to share her tips and techniques here.

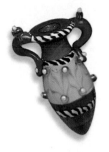

1— Use a pair of old wire cutters or nippers to gouge a $^1/_4$" mandrel on one end to make the surface rough and grabby.

2— Unroll a bundle of 4/0 steel wool and pull off a small strip.

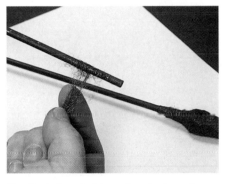

3— Catch the end of the steel wool strip on the roughed-up mandrel and start wrapping.

4— Tighten the wrap as you go by using your thumb and index finger to twist it in one direction.

5— Wrap the steel wool higher up the mandrel than the vessel's opening will be. Making the steel wool about $^3/_8$" thick at the neck area will make it easier to clean out later.

6— Keep adding steel wool to the areas you want to build up. Roll the whole thing on a table to tighten the form up and keep it symmetrical.

7— When you're satisfied with the shape, work really thick bead separator into the steel wool and then let it dry. You can sometimes find enough thick bead release in the cap of its bottle.

8— After the first coat of bead release has dried, dip the whole form into thinner-than-usual release. Tap the bare end of the mandrel on a table to help distribute the bead release evenly. Let the bead release dry thoroughly.

... continues on following page

9— Once dry, use a file or coarse emery board to even out the surface. Wear a dust mask for this step.

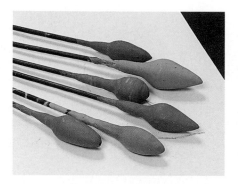

10— Give the prepared form a quick dip in water to create a smooth surface for easier cleaning of the vessel interior later. This picture shows a variety of vessel shapes and sizes.

11— Make some sketches with color details for your finished vessel. Assemble all the glass rods, stringers, twisties and tools needed.

12— Cure the bead release by preheating it in the flame. If some cracking and smoking occurs, you can ignore it. Begin to apply glass at the neck area of the vessel form.

13— Smooth and shape the neck with a paddle.

14— Apply glass to the shoulders of the bead. A graphite rod is helpful at this point for shaping. The rod shape helps to maintain a graceful inside curve where the neck and shoulders meet.

15— Barbara likes to decorate each zone as she goes. Here, she is applying a twistie to the neck.

16— A stringer trail is being added to the shoulder area.

17— The stringer trail is being raked into a pattern.

18— At this point, another stripe has been added below the shoulders and decorated with dots. The entire bottom of the vessel has been covered with transparent glass. The shape has been heated and is being refined with a paddle. Remember to stop frequently and give the parts of the vessel that you aren't working on a good heat. Cracks can be patched and healed but it rarely adds anything to the design.

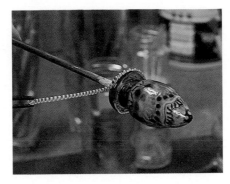

19— After all the zones have been decorated, build up the lip of the vessel. Finish it off with a twistie, if you like.

20— The vessel is now ready for handles. If you look closely, you can see four little pilot dots on the sides and lip of the vessel. This is Barbara's secret to straight even handles. (See "Almost Easy Vessel", page 133, steps 12-15). She says that if she skips this step, her handles are always "off".

21— Barbara likes to start the handles by first firmly attaching a glass rod to a pilot dot at the lip of the vessel.

22— Next, she arcs the glass rod down and attaches it to the pilot dot on the body of the vessel. After making this attachment, she then melts off the remaining glass rod.

23— A small graphite rod is used to finish shaping the handles and make them symmetrical. Any raised dot decorations that you wish to add to the handles or body of the vessel should be added now. For these vessels, Barbara likes to keep her annealing kiln at the high end of the annealing range. If the kiln is too cold, the vessel is more likely to crack. Anneal for 30-40 minutes and then ramp down very slowly. Having both thin and thick areas makes this bead particularly vulnerable to rapid changes in temperature.

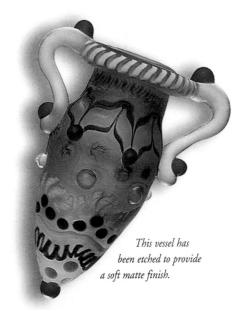

This vessel has been etched to provide a soft matte finish.

Cleaning:

Remove the mandrel and use a small hook type tool to pull out the remaining steel wool. Barbara made her own hook out of a 1/16" mandrel that she sharpened and bent into a small J shape.

Use dental tools or whatever you have handy to scrape as much of the bead release out as you can. This is the hard part. You may want to try different types of bead release and cleaners until you find the combination that works for you. You also may want to try making your first few vessels opaque until you find the best way of cleaning them out.

Get A Handle On It –*Various Artists*

Stringer Handle

courtesy of Ellen Black

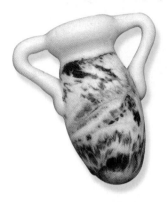

1— Add a ¾" length of pre-cut stringer to the side of a bead.

2— Heat just enough to soften the stringer and bend it over until it touches the bead.

3— Heat this second connection and use a pick to push it down.

4— Heat and shape the middle of the handle, using a pick as needed to keep the handle open.

5— The finished handles. Ellen suggests practicing handle-making on a simple cylinder bead. Make several handles on one bead until you get the hang of it.

Bead Handles *courtesy of Heather Trimlett who learned it from Stevi Belle*

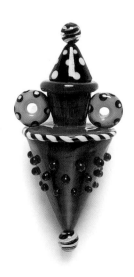

1— Make, decorate and anneal some small beads. Clean the small beads and return them to the annealer. Bring the annealer up to approximately 1000°F. Make your main bead. While keeping your main bead hot, use a large tweezers to remove one of the small beads from the annealer and slowly introduce it into the flame. Heat the side of the main bead and push the small bead into it.

2— The small bead handle is now attached to the side of the main bead.

Poked Handles

courtesy of Stevi Belle

1— Add a pea sized lump of glass to the side of a bead.

2— Use a small masher to flatten the lump to about ⅛" in thickness.

3— The flattened lump.

4— Heat the end of a tungsten pick to a red glow and start to poke it through the flattened handle.

5— Do the same to the opposite side of the handle. Continue heating and poking, alternating sides until the pick goes all the way through the handle.

6— The pick is now through the handle.

3— Remove a second small bead from the annealer and add it to the other side of the main bead.

4— Use a tweezers to straighten the small handle beads if needed.

5— The finished bead handles.

Get A Handle On It *(continued)*

Coiled Handle

courtesy of Brian Kerkvliet

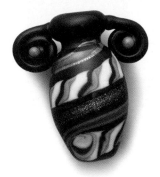

1— Add a 1¹/₂" length of precut stringer to the side of a bead.

2— Preheat a second stringer to use for rolling. Have this stringer warm enough to stick to the handle stringer, but still stiff enough to use as a rolling tool.

3— The handle stringer should be heated just enough to soften. Touch the rolling stringer to the tip of the handle stringer and start to roll it into a coil.

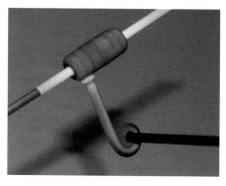

4— Continue rolling the handle stringer to form a coil, adding quick doses of heat as needed.

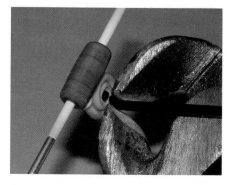

5— When the coil rests against the body of the main bead, use a nipper to snip the second stringer away from the coiled handle.

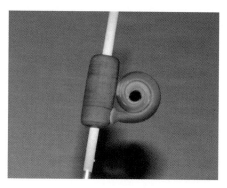

6— The first finished coiled handle.

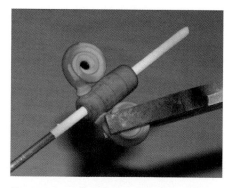

7— Add a second handle. Use a pliers to straighten the handles if necessary.

8— The finished coiled handles.

Bangle Bead —*Kim Miles*

These wonderful playful beads (a friend of mine calls them traffic jam toys) are a great exercise in heat control. They open up a lot of avenues for working with component parts.

1— Make some simply decorated rings on a large-diameter mandrel (works well for a large bangle bead). These rings need to be annealed, cleaned and then put back in the annealer. Slowly bring them up to slightly above the annealing temperature.

2— Make a cylinder bead with a dumbbell shaped end on one side. Make sure the cylinder is small enough for the rings to easily slide on. The cylinder also needs to be long enough to add the final end-cap without overheating the rings.

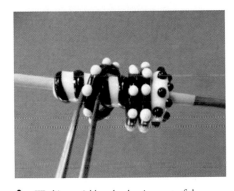

3— Working quickly, take the rings out of the annealer with slightly-warmed tweezers and slide them onto the cylinder bead. For the first try, just work with one ring. Later beads could be more ambitious with more rings.

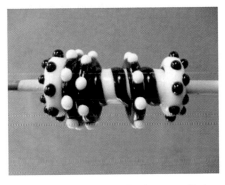

4— Add the second dumbbell end to your cylinder, while keeping the rest of the bead just warm enough so that it doesn't crack. You don't want the rings to get so hot that they fuse together.

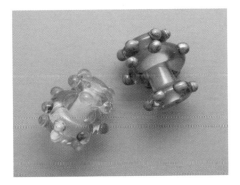

5— Baby bangle beads.

Make the rings fairly thick so they will be strong. Alternately, you can make the rings out of borosilicate glass. Since the rings will not actually be fused to the main bead compatibility is not an issue.

Fancy bangle with CZ dots.

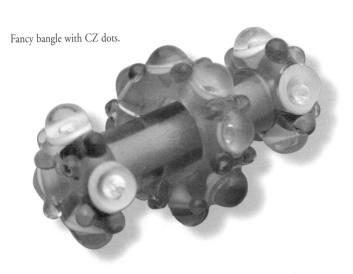

Low-Tech Photo Studio —*Mari Johnson*

Mari has a degree in commercial photography and owned a portrait studio until a move from Nebraska to Michigan. Not wanting to face the slow process of building up a business again, she sold the lights and light boxes, the canvas backgrounds, her camera and all the bells and whistles. Without her studio equipment, but needing to take good quality photos of her beads, Mari came up with this solution. She says the set up is inexpensive but works well. Mari feels that you can achieve professional looking photos with very little investment other than a good digital camera.

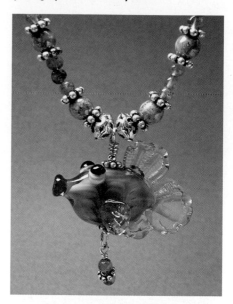

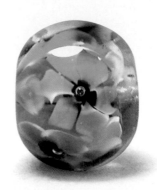

Photo Set-Up The light box consists of a rectangular translucent plastic storage container, 12" wide, 7¹/₂" high and 5" deep. Mari uses a regular desk lamp that swings over the top. Using a halogen bulb helps to maintain true color. The background paper is easily changed should you want a different color or texture.

This little photo studio sits on a shelf right next to Mari's computer. She can literally turn her chair, pop the disk of photos into the computer, edit and even post to the internet if she wants to. When she's through working, she stores her camera right inside the light box.

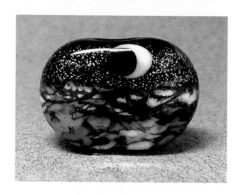

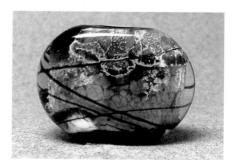

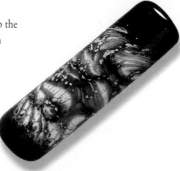

Glass Beadmaking *Safety*

If you are going to work with glass at high temperatures, potentially explosive gases and generally hazardous products, you owe it to yourself to get educated about using them safely. Detailed information about safety is beyond the scope of this book and you are encouraged to explore this topic further before setting up your own studio.

Your eyes, lungs and general health are precious commodities. Don't be ignorant or foolish about protecting yourself. Don't automatically accept anyone's word on proper protection; ask for their primary data sources. Do your own research. Ask as many questions as it takes to get answers until you feel confident in the information.

Eye Protection

Whenever you put cold glass into a hot flame, there's a chance that a small bit of glass might pop off. The single most important issue in eye protection for flameworkers is making sure that none of these little bits can find their way into your eyes. Good safety glasses need to protect your eyes from this kind of mechanical injury.

Hot glass emits a bright yellow light, called the "sodium flare." It is not generally considered harmful but can prevent you from actually seeing what you are doing. The higher the temperature, the brighter the sodium flare. As temperature goes up, other harmful radiation is emitted, typically in the infrared spectrum. Soft glass melts at a lower temperature than borosilicate glass, generating less of both the sodium flare and of harmful radiation. The exposure to infrared radiation increases as you move from soft to hard glass and from single-fuel torches to higher temperature systems.

Many lampworkers use safety glasses made out of didymium, a blend of rare earth metals, or other alternate lens materials that accomplish a similar effect. These lenses block transmission of the intense yellow sodium flare but vary in their ability to block the more hazardous infrared radiation. Contrary to popular belief, didymium glasses are not very effective at protecting your eyes from infrared radiation. There are

- Have a fire extinguisher in a handy place and know how to use it.
- Assemble a first aid kit with adequate supplies for minor cuts and burns.
- Have a source of ice or cold water nearby.
- Dress properly to avoid getting hot or sharp glass on bare skin.
- Keep long hair pulled back out of the way of the flame.
- Have your workspace adequately ventilated to prevent carbon monoxide build up.

... continues on following page

many available resources for safety information. It is a good idea to do some thorough research before embarking on any new hobbies. Start with product information and material safety data sheets (MSDS). If you use the internet for information, limit yourself to reliable sources, such as the US Government's Occupational Safety and Health Administration.

Respiratory Protection

Any open flame creates a certain amount of carbon monoxide and other potentially toxic byproducts of combustion. Be certain to have good ventilation in your studio, exhausting these fumes and introducing plenty of fresh replacement air.

Building a safe studio requires research and dedication. Your health and safety are worth it!

Enamels, frits, pixie dust or other powders require special considerations in ventilation and respiratory protection, containment and clean-up. This is all the more true when melting, vaporizing or fuming metals. Make sure that any mask or respirator you use is the right one for the product you are using. Respiratory devices must be

properly fitted in order to work effectively. The manufacturer of your safety product should be able to help you make the proper selection.

Sweeping or vacuuming powders can actually make things worse by allowing them to become airborne. They need to be wet-cleaned.

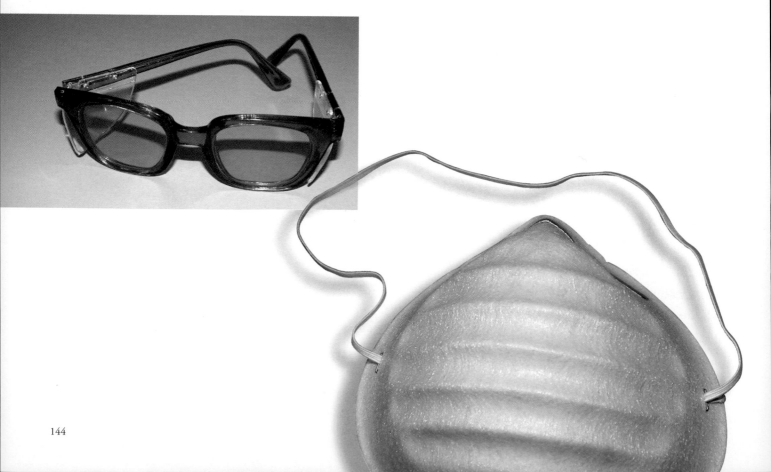

Glossary

Annealer A kiln used to slowly cool finished beads. Beads that are quickly cooled without an annealer may develop stress which can cause them to break. Slow cooling in an annealer prevents this stress and strengthens the glass.

Aventurine A glass matrix containing a super-saturated solution of metal flake, usually copper or chrome.

Bead release/separator Usually a clay and alumina mixture, separator is a coating applied to a mandrel so the finished bead, after cooling, can be removed from it.

Bicone A bead shape characterized by narrow tapered ends and a thick middle. Think of two cones with their wide bases joined together.

Blaschka German glass workers Leopold and son Rudolf Blaschka who supplied museums world-wide with their lampworked glass sea creatures. In the late 1800's they were commissioned to create botanical models for Harvard University. These breathtaking models were created over several decades and can still be viewed at the Harvard's Botanical Museum.

Cabochon A dome-shaped flat-backed stone.

Cane A rod-shaped piece of glass.

Casing The process of covering a core of glass with another layer of glass. Usually the casing is of transparent glass and emphasizes the underlying glass or pattern.

Ceramic overglaze A high temperature paint designed to be fired permanently onto a ceramic or glass base.

Ceramic paper Ceramic fibers pressed into a very thin sheet and used as a separator to prevent glass from sticking to a kiln shelf.

Coldworking Various processes used to create further detail in glass after it has been heat-formed and cooled. These processes include etching, engraving, grinding, gluing, etc.

Compatible glass Glass that has been formulated to expand and contract at a similar rate when heated and cooled. Compatibility prevents stress from developing when various glasses are melted together.

Core Vessel An ancient form of vessel in which hot glass has been trailed over a pre-made vessel-shaped core. Originally these cores were made of dung and straw. After the vessel has annealed the core is removed by scraping.

Cubic Zirconium ("CZ") A synthetic gem stone created under laboratory conditions with high heat and pressure.

Effetre An Italian manufacturer of soft glass rods used for lampworking. Formerly known as Moretti.

Electroforming A process of depositing metal (frequently copper) onto glass or other material. A conductive paste is painted onto selected decorative areas. The object is then placed into a bath containing the desired metal and an electric current is passed through the bath. The dissolved metal is attracted to the paste and attaches to the surface of the object in the selected areas.

Eye bead A bead with concentric dots representing eyes, frequently thought to protect the wearer from evil.

Fire polish Using heat to remove surface irregularities such as chill marks from glass.

Frit Glass that has been fractured into small granules. Rolling hot glass over frit creates a random spatter pattern.

Fume Using heat to vaporize metal onto a surface.

Fused glass Pieces of glass that have been heated to the point of sticking together. This process usually refers to sheet glass that has been cut, stacked in a pattern, and then fired in a kiln.

Gathering Using heat to collect a ball (gather) of molten glass on the end of a glass rod or tool.

Glory hole A high-heat chamber usually used in glassblowing to reheat glass pieces while they are being worked on.

Gold casting grain Small granules of gold generally used for casting jewelry pieces.

Intense black An especially dense formula of black glass. It can be worked very thin without fading to purple or brown.

Lampworking, flameworking, or torchworking A process of heating glass over a flame to make it pliable in order to create the desired shape. This process was originally done over oil lamps.

Latticino A special type of cane in which internal threads are twisted around each other to create a pattern. Originally these threads were made only in white. From the Italian word latte for milk.

Mandrels Stainless steel rods used to create the hole in lampworked beads. Molten glass is wound around these rods.

Marver A surface used for shaping hot glass. Hot glass is rolled over or pressed onto the usually flat smooth surface in order to smooth or shape it. Also used as a verb to describe the process itself.

Murrina/murrini A murrina is a slice of complex cane. Murrini is the plural form of murrina.

Punty A metal or glass rod which is attached to a hot glass work in progress, creating a temporary handle.

Reduction Glass colors are created with metal oxides. When colored glass is heated in an oxygen-deprived flame (a reduction flame), the flame reduces the oxides to their metallic state on the surface of the glass. Occasionally desirable, the color shifts range from a shiny metallic luster to dirty streaks.

Sheet glass Glass that has been rolled into thin sheets while molten.

Silver stain A color staining reaction between pure silver and molten glass of certain colors.

Stratified dots Dots that are stacked on top of one another.

Stringer Thin rods of glass, approx. $1/16$ - $1/8$" diameter.

Tabulate To flatten something into a tabular (tablet) shape.

Tack fusing Heating two pieces of glass until they are just stuck together but still retain their defined edges. The stage just before the glass softens and rounds over.

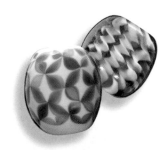

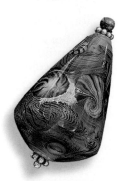

Contributing Artists

Lise Aagaard
Denmark

Dan Adams
Seattle, Washington

Kimberly Jo Affleck
Auburn, Washington

Yuichi Akagi
Japan

Donna Ballard, *More Than Beads*
Silverdale, Washington

Beau
Fox, Arkansas

Stevi Belle, *Belleisimo Glass*
Raton, New Mexico

Sher Berman
Deerfield, Illinois

Ellen Black,
Highland Park, Illinois

Jessica Bohus, *Blue Roan Studio*
Ganges, Michigan

Scott Bouwens, *Bearfoot Art*
Everett, Washington

Deb Bridge, *One by One*
Canada

Lani Ching, *I Ching Beads*
Portland, Oregon

Ofilia Cinta, *Pieces of Time*
Elmhurst, Illinois

Lauri Copeland, *Wild-Fire Designs*
Overland Park, Kansas

Gail Crosman-Moore
Flying Frog Glassworks
N. Orange, Massachusetts

Ann Davis, *Ohmega*
Springfield, Virginia

Alethia Donathan, *DACS Beads*,
Honolulu, Hawaii

Patti Dougherty
Elkins Park, Pennsylvania

Deanna Griffin Dove
Griffin Dove Designs
Atlanta, Georgia

Pam Dugger, *Nature's Flame*
Hollywood, Florida

Char Eagleton
Mt. Carroll, Illinois

Diana East
England

Joan Eckard, *Moth Woman*
Mechanicsburg, Pennsylvania

Beverley Edwards
Mirage Glass and Metal
England

Lynne Elliott
Wickenburg, Arizona

Leah Fairbanks, *Gardens of Glass*
San Rafael, California

Kim Fields, *North Fire Designs*
Lincolnwood, Illinois

Zoelle Fishman
Northbrook, Illinois

Amber French
Burleson, Texas

Greg Galardy, *Heart Bead*
Arcata, California

Jinx Garza
Columbia, Maryland

Mary Gaumond
Sayreville, New Jersey

Jennifer Geldard, *Glassgirls Studio*
W. Brookfield, Massachusetts

Andrea Guarino
Port Townsend, Washington

Hiroko Hayashi
Japan

Bronwen Heilmann
Ghost Cow Glassworks
Tucson, Arizona

Molly Heynis, *Heritage Glass*
New Braunfels, Texas

Tom Holland
Fox, Arkansas

Al Janelle, *Ambeadextrous*
Austin, Texas

JoElla Johnson
Sacramento, California

Kathy Johnson, *Glass Expressions*
Seattle, Washington

Mari Johnson
New Lenox, Illinois

James Allen Jones, *Bullfrog Beads*
Portland, Oregon

David and Rebecca Jurgens
LandS Art
Kingston, Washington

Mary Karg
Loveland, Ohio

Holly Kempson
W. Orange, New Jersey

Sylvie Elyse Lansdowne
Smyrna, Georgia

Kristina Logan
Portsmouth, New Hampshire

Eleanor MacNish, *Ellie Mac*
Albuquerque, New Mexico

Michael Mangiafico, *FiG Studios*
Pittsburgh, Pennsylvania

Kerri Martinez
Arlington, Texas

Melissa Perry McQuilken
Stratton, Maine

Maureen McRorie
Mr. Beady Glass Art
Orlando, Florida

Travis Medak
Tacoma, Washington

Kate Fowle Meleney
Saunderstown, Rhode Island

Budd Mellichamp
Tallahassee, Florida

Kim Miles
Taos, New Mexico

Caroline Noga
Fox Lake, Illinois

Donna Nova, *Donna's Designs*
Washington D.C.

Akihiro Ohkama
Glass Studio "Hand"
Japan

Johnny Olson
Larkspur, Colorado

Ryo Ono
Japan

Kristen Frantzen Orr
Mesa, Arizona

Kim Osibin, *Gaia Glassworks*
San Rafael, California

Karen Ovington
Ovington Glass Studio
Chicago, Illinois

Janice Peacock
Lafayette, California

Sharon Peters
Alameda, California

Nancy Pilgrim, *Fantasy Beads*
Tempe, Arizona

Peggy Prielozny, *Glass Gardens*
Morton Grove, Illinois

Isis Ray, *Raven's Dream*
Carnation, Washington

Doug Remschneider
Albuquerque, New Mexico

Rene Roberts
Albion, California

Tracey Rodgerson, *Purple Creek*
Swartz Creek, Michigan

Peggy Rose, *Peggy's Custom Designs*
Camas, Washington

Sage
Fox, Arkansas

Tomoko Saito
Japan

Emiko Sawamoto, *Ruri Glass Studio*
Berkeley, California

Terri Caspary Schmidt
Albuquerque, New Mexico

Larry Scott
Seattle, Washington

Sandra Seaman, *One Bead at a Time*
West Lawn, Pennsylvania

Stephanie Sersich
Portland, Maine

Eric Seydoux, *Ver Et Framboise*
Switzerland

Ryohsuke Shigedomi
Japan

Barbara Becker Simon
Cape Coral, Florida

Cheryl Spence, *Odyssey Designs*
Hyattsville, Maryland

Lisa St. Martin, *Lisa St. Martin Glass*
Reston, Virginia

Karen Stavert, *Hot Glass Beads*
Palm Beach Gardens, Florida

Matt Stoffolano
Big Bend, Texas

Loren Stump
Elk Grove, California

Jill Symons
PI Lampwork

Sylvus Tarn, *Rejiquar Glass*
Detroit, Michigan

Corina Tettinger, *Corinabeads*
Friday Harbor, Washington

Nancy Tobey
Ayer, Massachusetts

Mitra Totten
Apopka, Florida

Heather Trimlett
El Cajon, California

Caryn Walsh
Apache Junction, Arizona

Pati Walton, *Pati Walton Designs*
Larkspur, Colorado

Debbie Weaver, *Fern Hill Studio*
Middletown, Maryland

Mary Elyse Weiss, *Whimsical Glasswerks*
Lawrenceville, Georgia

Kim Wertz, *Heart Bead*
Arcata, California

Audrie Wiesenfelder
Audrie Wiesenfelder Glass
Skokie, Illinois

Kate Drew Wilkenson
Bisbee, Arizona

Beth Williams, *Beth Williams Studio*
Gloucester, Massachusetts

John Winter, *Winterglas*
Potomac, Maryland

Lea Zinke, *Jewelz*
Clearwater, Florida

Nicole Zumkeller, *Ver Et Framboise*
Switzerland

Photography and Jewelry Credits

Front Cover Images

1. Sharon Peters: Janice Peacock
2. Leah Fairbanks: George Post
3. Heather Trimlett: Melinda Holden
4. Loren Stump: Rich Images
5. Emiko Sawamoto: Rich Images
6. Greg Galardy: Greg Galardy
7. James Jones: Martin Konopacki
8. Dan Adams: Roger Schreiber
9. Terri Caspary Schmidt: Martin Konopacki
10. Stevi Belle: Andrew Kingsbury
11. Eric Seydoux: Eric Seydoux
12. Sage: Tom Holland

Page 2 Caryn Walsh: Martin Konopacki

Page 3 Heather Trimlett: Melinda Holden

Page 4 Goblets by Jerry Catania: Ed Weisbart

Page 5 *Top to Bottom*
Tracey Rodgerson: Martin Konopacki
Karen Stavert: Martin Konopacki
Melissa Perry McQuilken: Martin Konopacki
Sandra Seaman: Martin Konopacki
Jill Symons: Martin Konopacki

Page 6 *Top to Bottom*
Lauri Copeland: Martin Konopacki
John Winter: Martin Konopacki
Jinx Garza: Martin Konopacki
David and Rebecca Jurgens: Martin Konopacki
Melissa Perry McQuilken: Martin Konopacki

Page 7 Dan Adams: Roger Schreiber

Page 8 Dan Adams: Roger Schreiber

Page 9 Kristina Logan: Paul Avis

The Beads

Page 10
1. Andrea Guarino: Andrea Guarino
2. Stephanie Sersich: Robert Diamante
3. Sylvus Tarn: Martin Konopacki
4. Maureen McRorie: Martin Konopacki
5. Jinx Garza: Martin Konopacki

Page 11
1. Leah Fairbanks: George Post
2. Tracey Rodgerson: Martin Konopacki
3. Sylvie Elise Lansdowne: Robert Diamante
4. Johnny Olson: Martin Konopacki
5. Andrea Guarino: Andrea Guarino
6. Kristen Frantzen Orr: David S. Orr
7. Lauri Copeland beads, Doug Remschneider goblet: photo by Martin Konopacki

Page 12
1. Eleanore MacNish: David Nufer
2. Sharon Peters: Janice Peacock
3. Joan Eckard: Martin Konopacki
4. Kerri Martinez: Martin Konopacki
5. Mary Elyse Weiss: Joe Weiss
6. Diana East: Diana East

Page 13
1. Leah Fairbanks: photos by George Post; top left gold work by Karen Keit; top middle metal work by Deborah Nishihara
2. Pati Walton: seed bead work by Marcia Katz, photo by Martin Konopacki
3. Donna Nova: Martin Konopacki
4. Mitra Totten: Martin Konopacki
5. Donna Ballard: Martin Konopacki
6. Peggy Prielozny: Martin Konopacki
7. Akihiri Ohkama: Martin Konopacki
8. Joan Eckard: Martin Konopacki

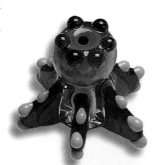

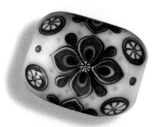

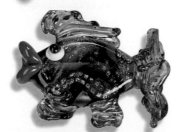

Page 14

1. Lauri Copeland: Martin Konopacki
2. Kathy Johnson: Martin Konopacki
3. Sandra Seaman: Martin Konopacki
4. Beverley Edwards: Martin Konopacki
5. Al Janelle: Martin Konopacki
6. Caroline Noga: Martin Konopacki
7. Kristen Frantzen Orr: Ralph Rippe
8. Audrie Wiesenfelder: Martin Konopacki
9. Gail Crosman-Moore: Gail Crosman Moore

Page 15

1. Kim Fields: Martin Konopacki
2. Deanna Griffin Dove: Robin Campo
3. Barbara Becker Simon: Rob Stegmann
4. Lea Zinke (garden beads) and Susan Davis (wire work and purple/green enamel beads): Martin Konopacki
5. Pati Walton: Martin Konopacki
6. Leah Fairbanks: Martin Konopacki
7. Peggy Prielozny: Martin Konopacki
8. Donna Ballard: Martin Konopacki
9. Melissa Perry McQuilken: Chris DeSimone

Page 16

1. Beth Williams: Andrew Swaine
2. Matt Stoffolano: Martin Konopacki
3. Ann Davis: Martin Konopacki
4. Kim Osibin: Phil Schneider
5. James Jones: Martin Konopacki
6. Eric Seydoux: Eric Seydoux
7. Scott Bouwens: Martin Konopacki

Page 17

1. Stevi Belle: Jerry Anthony
2. Andrea Guarino: Andrea Guarino
3. Eric Seydoux: Eric Seydoux
4. Lauri Copeland: Martin Konapacki
5. Mary Karg: Martin Konopacki
6. Ofilia Cinta: Martin Konopacki
7. Audrie Wiesenfelder: Martin Konopacki
8. Kate Fowle Meleney: Martin Konopacki
9. Karen Ovington: Martin Konopacki

Page 18

1. Yuichi Akaga: Martin Konopacki
2. Stephanie Sersich: Robert Diamante
3. Diana East: Diana East
4. Amber French: Martin Konopacki
5. Ann Davis: Martin Konopacki
6. Char Eagleton glasswork, Deane King silverwork: Martin Konopacki
7. Mary Karg: Martin Konopacki
8. Caryn Walsh: Martin Konopacki

Page 19

1. Debbie Weaver: Jerry Anthony
2. Loren Stump: Rich Images
3. Ryohsuke Shigedomi: Martin Konopacki
4. Sharon Peters: Janice Peacock
5. Stephanie Sersich: Robert Diamante

Page 20

1. Rene Roberts: brooch photo by Hap Sakwa; necklace photo by George Post
2. Bronwen Heilman: David S. Orr
3. Cheryl Spence: Martin Konopacki
4. Kim Affleck: Martin Konopacki
5. Mary Karg: Martin Konopacki
6. Joella Johnson: Rich Images
7. Michael Mangiafico: Joelle Levitt

Page 21

1. Lynn Elliott (knife in collaboration with her husband, Alan Elliott): photos by Jeff Scovil
2. Corina Tettinger: Corina Tettinger
3. Andrea Guarino: Andrea Guarino
4. Travis Medak: Martin Konopacki
5. Dan Adams beads, Chuck Domitrovich silver work: photo by Roger Schreiber

Page 22

1. Travis Medak: Martin Konopacki
2. Terri Caspary Schmidt: Martin Konopacki
3. Kate Fowle Meleney: Martin Konopacki
4. John Winter: Martin Konopacki
5. Kristina Logan: Paul Avis
6. Stephanie Sersich: Robert Diamante

The Artists

24. Emiko Sawamoto: all photos by Rich Images except peacock bead by Emiko Sawamoto
25. Kristen Frantzen Orr: David S. Orr
26. Tom Holland: Tom Holland
27. Sage: all photos by Tom Holland except bottom left corner grouping by Alice Korach
28. Leah Fairbanks: George Post
29. Stevi Belle: upper vessels by Jerry Anthony; tabular bead by Martin Konopacki; Glass Gals and lower vessel by Andrew Kingsbury
30. Beth Williams: all photos by Andrew Swaine except Heart Fibula by Paul Avis
31. Kristina Logan: Paul Avis
32. Pam Dugger: Pam Dugger
33. Sharon Peters: Janice Peacock
34. Lani Ching: Martin Konopacki
35. James Jones: Martin Konopacki
36. Stephanie Sersich: Robert Diamante
37. Jessica Bohus: Martin Konopacki
38. Lisa St. Martin: Jerry Anthony
39. Alethia Donathan: Hal and Masayo Lum
40. Nicole Zumkeller and Eric Seydoux: Eric Seydoux

41. Kim Affleck: Martin Konopacki
42. Janice Peacock: Janice Peacock
43. Mary Gaumond: Martin Konopacki
44. Barbara Becker Simon: Rob Stegmann
45. Ofilia Cinta: Rich Images
46. Nancy Pilgrim: Necklace by Ralph Gabriner; black and white bead by Nancy Pilgrim
47. Heather Trimlett: Melinda Holden
48. Beau: top left, large bead and red beads by Robert Liu; top right by Sage; blue/clear in group of three at bottom by Tom Holland
49. Isis Ray: Isis Ray
50. Budd Mellichamp: all photos by Budd Mellichamp except top left and vertical faceted by Martin Konopacki
51. Pati Walton: Martin Konopacki
52. Rene Roberts: Hap Sakwa
53. Larry Scott: all photos by Roger Schreiber except top right by Martin Konopacki
54. Kim Wertz: Greg Galardy
55. Greg Galardy: Greg Galardy
56. Cheryl Spence: pendants by Rich Images; Large Pebble picture by Don Spence; top right by Martin Konopacki
57. Michael Mangiafico: Joelle Levitt
58. Kate Fowle Meleney: Martin Konopacki
59. Karen Ovington: Tom Van Eynde
60. Dan Adams beads, Chuck Domitrovich silver work: Roger Schreiber
61. Al Janelle: Martin Konopacki
62. Terri Caspary Schmidt: Martin Konopacki
63. Kim Fields: Martin Konopacki
64. Diana East: all photos by Martin Konopacki except large bead on right by Lucy Hunt
65. Loren Stump: Rich Images
66. Ed Weisbart

Techniques

67. Heather Trimlett: Melinda Holden
68. Round Round Action: Kathleen Dyer; left still by Kathleen Dyer; middle and right stills by Ed Weisbart

69. Tapered Barrel action by Ed Weisbart; stills by Martin Konopacki; beads made by Travis Medak
70. Snipped Batwing action by Walter Plotnik; stills by Daniel Marder
71. Melon Bead action by Ed Weisbart; still by Martin Konopacki
72-73. Easy Heart Bead: Ed Weisbart; beads by Cindy Jenkins
74. Precise Dots: action by Kathleen Dyer; still by Martin Konopacki
75. Dot Variations: action by Ed Weisbart; upper still photo by Ed Weisbart, lower still photo by Roger Schreiber
76. Striped Bead: Ed Weisbart
77. Triangle Dot Bead: action and still by Ed Weisbart
78. Fish Scale Bead: action and stills by Ed Weisbart; beads by Cindy Jenkins
79. Frit Stringer: action and stills by Ed Weisbart
80. Zigzag: action and stills by Ed Weisbart; beads by Cindy Jenkins
81. Rainbow Bead: action by Ed Weisbart; still by Corina Tettinger
82. Petal Plunge: action and still by Ed Weisbart; beads by Cindy Jenkins
83. Floral CZ: action and still by Rick Vanderburg
84. Stratified Star: Tom Holland
85. Twisted Bubble Dot: action and still by Ed Weisbart; beads by Cindy Jenkins
86. Tiny Trails: action and still by Ed Weisbart; bead by Cindy Jenkins
87. Spider Raked Bead: action by Sage; still by Tom Holland
88-89. Pulled Floral Pendant: action and still by Ed Weisbart
90. Landscape: action and still by Ed Weisbart
91. Element: action and still by Ed Weisbart
92. Webwork: action by Ed Weisbart; still by Martin Konopacki
93. Intense Black: action and still by Ed Weisbart
94. Lapidary Bead: action and bottom right still by Ed Weisbart; upper two stills by Martin Konopacki; bottom bead by Cindy Jenkins
95. Stone Bead: action and still by Richard Kempson
96. Patterned Enamel: action and still by Ed Weisbart

150

Back Cover Images

Action photos of Larry Scott placing dots: Kathleen Dyer; still photos by Andrea Guarino of her own beads

Inner Flap Images

Portrait of Cindy Jenkins: Martin Konopacki

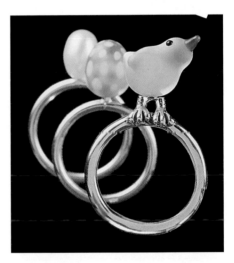

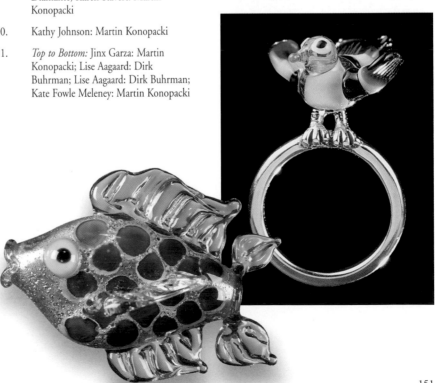